IMAGES
of America

NORUMBEGA PARK AND TOTEM POLE BALLROOM

ON THE COVER: The spinning Crazy Cups ride, one of the attractions in an array that included a carousel, a Lindy Loop, and a miniature roller coaster, entertained visitors to Norumbega Park in the 1950s. (Photograph by Steve Plimpton.)

IMAGES
of America

NORUMBEGA PARK AND
TOTEM POLE BALLROOM

Clara Silverstein and Sara Leavitt Goldberg
with Historic Newton

ARCADIA
PUBLISHING

Copyright © 2021 by Clara Silverstein and Sara Leavitt Goldberg
ISBN 978-1-4671-0633-7

Published by Arcadia Publishing
Charleston, South Carolina

Printed in the United States of America

Library of Congress Control Number: 2021930786

For all general information, please contact Arcadia Publishing:
Telephone 843-853-2070
Fax 843-853-0044
E-mail sales@arcadiapublishing.com
For customer service and orders:
Toll-Free 1-888-313-2665

Visit us on the Internet at www.arcadiapublishing.com

In memory of Robert "Bob" Pollock.

CONTENTS

ACKNOWLEDGMENTS

The idea for this project came about several years after one of Historic Newton's most popular exhibits, Return to Norumbega, had been turned into a traveling exhibit that consistently brought smiles to its viewers. Both exhibits and this book were made possible by the talents of former curator Susan Abele and the donation in 2005 of Robert "Bob" Pollack's papers. Pollack, who grew up near the park and worked there as a teenager, spent 15 years collecting materials about the park and wrote an unpublished manuscript. We incorporated much of his work into this book. We also referred to the video history of the park, *Return to Norumbega*, that Joe Hunter created in 2005 in consultation with Pollack. Some of the individual reminiscences come from those who attended the Norumbega Park Centennial celebration on June 15, 1997.

The authors wish to acknowledge the inclusion of several photographs that indict the park, its owners, and its audiences and patrons in the propagation of racial and cultural stereotypes that were accepted at that time. We include these for historical background, not because we condone the attitudes or behavior that they represent.

All images are from the collections of the Jackson Homestead, and include work created by professional photographers who worked at the park: William, Edmund, and Robert Hawes; Charles Darling; and Stephen W. Plimpton; as well as park manager William White. We would like to thank Roger, Ned, and Lee Farrington, children of former park owner Doug Farrington, and Historic Newton volunteer Ralph Chiumenti. Thanks also go to editor Stacia Bannerman for keeping us on track and focused. We would also like to thank our families; our director, Lisa Dady; the Joint Board at Historic Newton; and our colleagues, Kate Bresee, Anna Cheung, Cynthia Cowan, Ronnie Dooley, Marya Van't Hul, Benjy Kantor, and Kelsey Archer Merriam, for allowing us to indulge in this passion project during a very trying time for us all—we couldn't have done it without you!

INTRODUCTION

Built in 1897 to attract riders to the end of the new Commonwealth Avenue Street Railway in Newton, Massachusetts, Norumbega Park quickly became its own destination. In its 66 years of operation, the park beside the Charles River in Auburndale grew into a regional favorite, especially for families. The Totem Pole Ballroom opened in 1930, attracting nationally renowned big bands and setting a standard of elegance and prestige. Many couples who later married went on their first dates at the Totem Pole.

One of many "trolley parks" that opened along trolley lines near American cities around the turn of the 20th century, Norumbega Park outlasted much of the competition because of its reputation for cleanliness and family-friendly fun. As president of the Commonwealth Avenue Street Railway (later Middlesex & Boston) for 30 years, Adams D. Claflin, the son of a former Massachusetts governor, played a key role in Norumbega Park's development and management. Claflin, business partner Leonard Ahl, and park manager Carl Alberte emphasized quality. To discourage rowdiness, constables enforced a strict no alcohol policy inside the park, and later also in the ballroom. The park took special care to make women feel comfortable at a time when they were just beginning to venture out without male escorts. "No objectionable characters mar the pleasure of women or children; perfect order is maintained and everybody is happy continually," a brochure stated.

Many elements converged to help make Norumbega Park, open seasonally from May through September, an instant success. A typical summer weekend in the park's first five years brought 40,000 visitors. The working classes in Boston finally had enough leisure time to enjoy a weekend outing, as around this time many employers began giving workers a half-day off on Saturdays. Norumbega also made the most of its natural setting along the Charles River. In the 19th century, a national public park movement began emphasizing the health and social benefits of public green spaces.

Norumbega Park advertised itself as "the ideal popular resort" and "the most perfect park in the country," catering to customers who wanted a tree-lined, riverside escape from their increasingly crowded neighborhoods. Newton experienced a boom in the 1890s, adding approximately 9,000 residents to bring the population to 33,000. Between 1900 and 1910, Boston's population increased by 110,000. An article in the *Newton Graphic* on June 25, 1906, talked about the restorative qualities of a Sunday at the park: "Many a patron boasts that it puts new life into him . . . he returns to the city refreshed and feeling at peace with the world."

In the park's early years, visitors also came for the latest entertainment: a carousel with hand-carved wooden animals, a penny arcade, band concerts, live vaudeville shows, short movies, and a zoo. The park also rented canoes. Though in 1902 Claflin and his associates opened a second location, Lexington Park, in nearby Lexington, Massachusetts, that park only lasted until 1920. Norumbega's regional competition included Canobie Lake Park (Salem, New Hampshire), Whalom Park (Lunenberg, Massachusetts), Salem Willows (Salem, New Hampshire), and Paragon Park

(Nantasket Beach in Hull, Massachusetts). Despite the popularity of these parks, Norumbega continued to thrive because it continually reinvented itself.

By the 1920s, bigger rides, such as a Ferris wheel, and daredevil acts including acrobats and high divers brought in new thrill seekers and spectators to Norumbega Park. The grounds expanded to include a ballfield that hosted local teams and the Totem Pole Belles women's softball team in the late 1930s. The park also hosted a miniature golf course and a midway for games of skill, such as Skee-Ball. Many community groups used the picnic grounds for socials and other events.

As the Great Depression cut into attendance, the park's directors in 1930 made the bold decision to turn the open-air theater into the Totem Pole Ballroom. By presenting a roster of nationally famous swing bands in elegant surroundings, the Totem Pole became even more of an attraction than Norumbega Park. For many people, the atmosphere proved nothing short of magical. "They come by droves and hundreds, the boys fresh and bright now in their white summer coats, the girls timorous and lovely, some in their first party dresses. . . and as they dance under the changing colors of the ballroom lights, there is no prettier sight this side of the Taj Mahal in the moonlight," wrote George Clarke in the *Boston Sunday Advertiser* on June 22, 1952.

Changing popular tastes in the late 1940s led to a slow decline in attendance at the Totem Pole Ballroom and Norumbega Park. Throughout the 1950s, the public was finding new options for entertainment, especially television and automobile trips to far-flung destinations. Population growth in Newton in the 1950s made the land occupied by Norumbega Park more valuable for development than for amusements. Newton residents fought to have the land taken by eminent domain or developed on a small scale, but market forces prevailed. Peter Kanavos of the Newton Corporation purchased the property in 1960. The park continued to operate until 1963 and the ballroom until 1964. Fire destroyed the ballroom and some of the park's buildings before construction of a new Marriott Motor Hotel began in 1966.

The story of Norumbega Park and the Totem Pole Ballroom mirror popular trends in the 20th century. A growing network of trolley lines made a park like Norumbega accessible to the masses. Management adapted to changing tastes, over the years offering an impressive range of live entertainment that included vaudeville, aerialists, and dog and pony shows. Mechanical rides also showed similar range, from a miniature train to a somewhat frightening ride named Davy Crockett's Nightmare. The Totem Pole Ballroom proved prescient for the era of big band music and brought in new audiences.

The park's closing in the early 1960s signaled a change in the leisure industry as well as a change in Newton's landscape. For 66 years, the park stood as a major landmark and resource for local jobs as well as fun excursions. Reunion committees re-created the Totem Pole Ballroom in 1988 and again in the 1990s for nostalgia seekers. This book helps preserve some of their memories, while it also traces the full story of the park on the banks of the Charles River that enchanted generations of visitors.

One

Nature's Own Resort

In 1895, the extension of Commonwealth Avenue into Newton neared completion with much fanfare. The *Boston Globe* described the new boulevard from the Chestnut Hill Reservoir to the Charles River as "Newton's Pride." Designed by celebrated landscape architect Frederick Law Olmsted, the avenue became the principal east–west road through the middle of Newton. To address the need for reliable public transportation along it, the Commonwealth Avenue Street Railway was chartered in 1895. Its president, Adams D. Claflin, grew up in part at his family's summer estate in Newtonville. Anticipating low ridership on Saturdays and Sundays, Claflin and his partners decided to add an amusement park to the end of the line to attract weekend business. Claflin and Leonard D. Ahl purchased land along the Charles River approximately 12 miles from Boston for the park. Construction began in the winter of 1895–1896.

The name "Norumbega" came from Norumbega Tower, a stone structure built in 1889 as a tribute to the Vikings. In the 1890s, Massachusetts residents took great pride in the idea that the Viking explorers had "discovered" their home state, though historians later disproved that Vikings had visited New England, much less built cities along the Charles River. Yet in searching for a name for the new amusement park, the founders noted its location directly across the river from Norumbega Tower and decided to take advantage of the popular name.

Construction of the park took approximately 16 months. The architect, Samuel J. Brown, had also designed private residences in Newton. The plan called for a restaurant, an outdoor theater, a structure to house a merry-go-round, a women's cottage for restrooms and other amenities, enclosures for zoo animals, and a boathouse. Landscape architect Franklin Brett transplanted almost 1,000 trees and shrubs to add to the area's natural beauty.

The park opened on June 17, 1897, to attract people in Greater Boston in search of a diversion. The trolley ride itself was advertised in a 1906 promotional picture book as part of the fun: "The ride is most perfect, exhilarating, and satisfying, passing through the residential sections of the wealthy, thence through the prettiest portions of Newton."

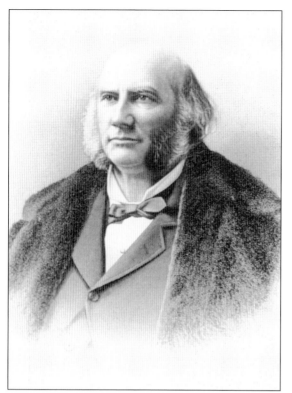

Eben Norton Horsford, born in 1818, became a science professor at Harvard College in 1846. Convinced that the Vikings had landed in New England, he combed the banks of the Charles River for evidence. His 1890 book *The Discovery of the Ancient City of Norumbega* advanced his theory. Archaeologists later found no evidence of a settlement in New England, though they did note that the Vikings likely did reach Newfoundland.

This card shows one of Eben Horsford's inventions, Horsford's Acid Phosphate, a treatment for indigestion. Horsford's formula for baking powder, which became the Rumford brand, made him quite wealthy. A brilliant chemist, he registered more than 30 patents and also devised the standard marching ration for the Union army during the Civil War.

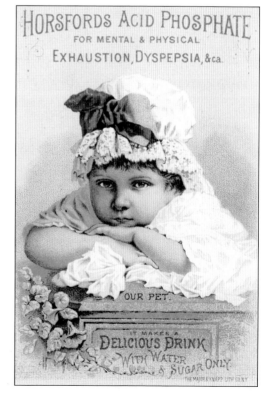

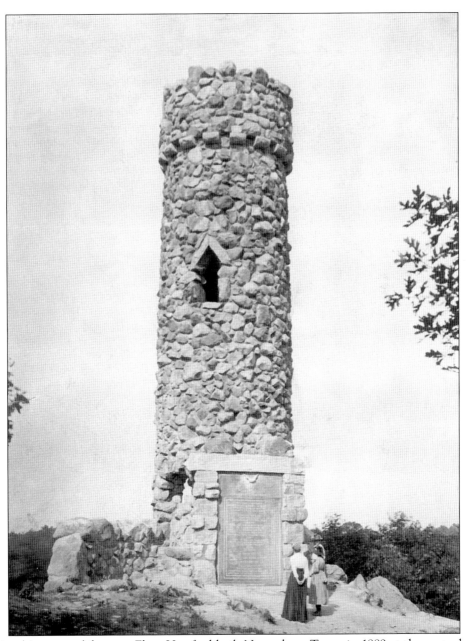

Using his personal fortune, Eben Horsford built Norumbega Tower in 1889 at the spot where he believed the Vikings had built a fort. Across the river from Newton, the site straddles the boundary between Waltham and Weston. The tower was named after the legendary lost Norse city of Norumbega. The inscription at the base reads in part, "Norumbega. City-Country-Fort-River. Latest Norse Ship Returned to Iceland in 1347." One of Horsford's followers, the eminent 19th-century poet John Greenleaf Whittier, penned two poems about the city of Norumbega. He wrote in a letter to Horsford, "That adventurous Scandinavians visited New England and attempted a settlement here hundreds of years before Columbus is no longer a matter of doubt. Thy discovery of traces of that early settlement is a matter of great archaeological interest, and the memorial Tower and Tablet may well emphasize the importance of that discovery."

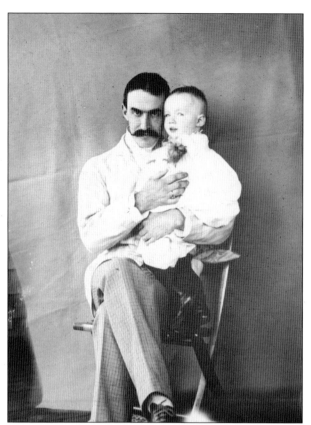

As the son of former Massachusetts governor William Claflin, Adams Claflin, shown with his daughter Maude in 1891, had prestige and powerful connections that could help him advance his business interests. At the Old Elms family estate in Newtonville, his parents entertained US senator Charles Sumner, author Harriet Beecher Stowe, and many other prominent guests.

Samuel J. Brown, the architect of Norumbega Park, also designed the shingle-style home at 156 Grant Avenue in Newton Centre where Adams Claflin and his family lived. The home is now listed in the National Register of Historic Places. The Harvard-educated Claflin remained president of the Commonwealth Avenue Street Railway and its successor corporations for 30 years.

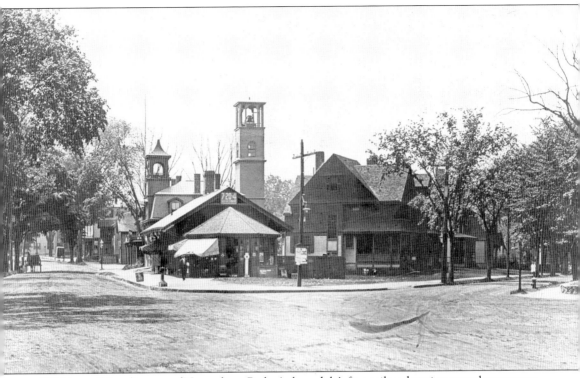

Within walking distance of Norumbega Park, Auburndale's first railroad station served passengers on the Boston & Albany Railroad, which also stopped at Riverside, West Newton, Newtonville, and Newton Corner. Commuters used this railroad to travel from Newton to Boston for work, theater, and shopping. Residents of the southern villages of Newton used the Brookline Circuit or Highland Branch, which ran from Riverside to Boston via Waban, Newton Highlands, Newton Centre, Chestnut Hill, and Brookline. For traveling short distances, the horse and buggy was the most common form of transportation in Newton in the 1890s. The park capitalized on the public's growing reliance on trains and street trolleys to go longer distances, especially to and from Boston. An early brochure noted that the park was easily accessible by trolley lines within a radius of 50 miles, especially from the subway at Park Street Station in Boston.

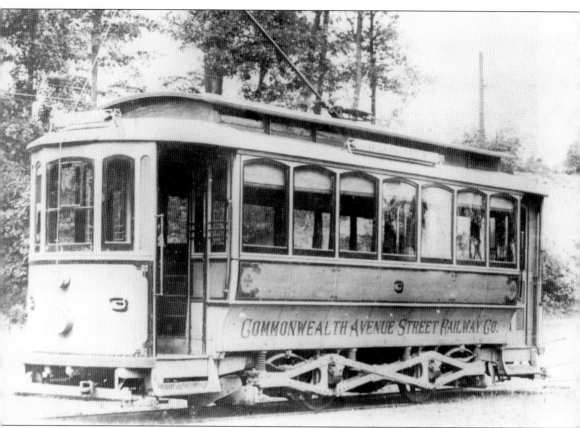

To prepare for weekend passengers to Norumbega Park, the Commonwealth Avenue Street Railway built a double track from Lake Street at the Boston boundary out to Auburn Street. The tracks were also extended to the park entrance. The improved tracks proved to be a boon to real estate development. In 1895, there were only 24 homes on Commonwealth Avenue between Auburndale and Boston. Once transportation improved, more followed. The trolley to Norumbega Park ran from Brighton west along Commonwealth Avenue. The tracks were built between the main road and the carriage lane; the area is now covered by a grassy median strip. Riding an open-air car out to the park became part of the experience. "The ride by electrics [is] the most beautiful out of Boston," a brochure advertised.

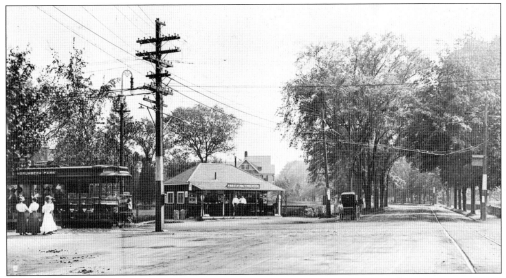

The Commonwealth Avenue Street Railway Company initially generated its own power at a plant on Cummings Road near Newton City Hall but later found it cheaper to purchase power from the Edison Electric Illuminating Company. That company later became Boston Edison. The trolleys continued running until 1930, when they were replaced by buses.

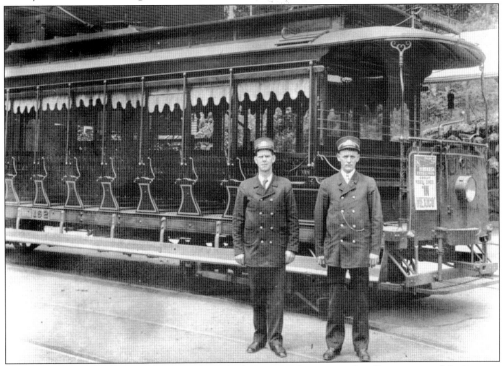

Newton resident Harry Bailey (right) worked as a conductor on the Commonwealth Avenue Street Railway Company. Bailey's supervisor, fellow Newton resident Newell C. Smith, is generally credited with convincing Adams Claflin and Leonard Ahl to build the amusement park on the banks of the Charles River in Auburndale. The site's location at the end of the trolley line and its natural beauty made it ideally suited for the park.

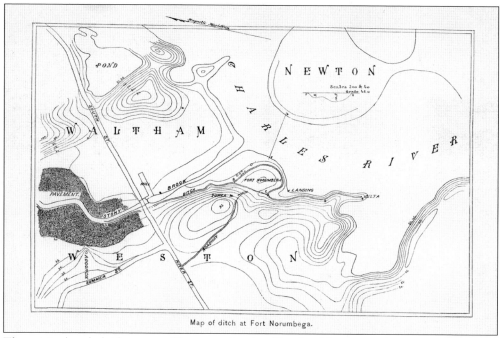

Map of ditch at Fort Norumbega.

The original park, laid out on a 10-acre peninsula of land in Newton, took its name from "Fort Norumbega" and the Norumbega Tower on the opposite side of the Charles River in Weston. These are the historic homelands of the Massachusett, Nipmuc, and Wampanoag native peoples, who called the river Quinobequin. Their descendants are still present in our community.

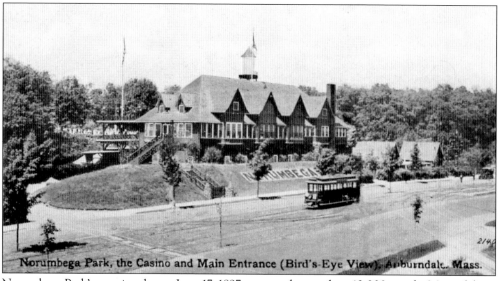

Norumbega Park, the Casino and Main Entrance (Bird's-Eye View), Auburndale, Mass.

Norumbega Park's opening day on June 17, 1897, attracted more than 12,000 people. Most of them traveled by streetcar, which caused a serious problem when the park closed at 10:00 p.m. The railway company only owned 12 cars, each designed to seat 45 passengers with standing room for approximately 20 more. It took until 5:00 a.m. for the last of the patrons to be accommodated.

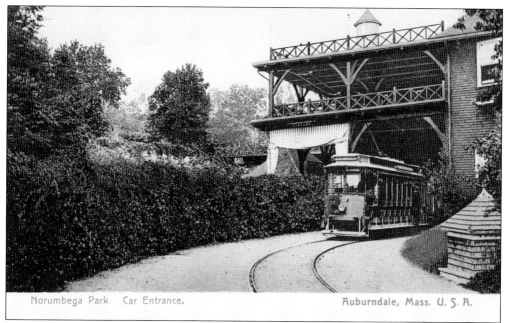

Norumbega Park. Car Entrance. Auburndale, Mass. U. S. A.

As the park's popularity increased, the Commonwealth Avenue Street Railway added larger cars with 15 benches seating six people abreast. Inside the park, the original layout included a main entrance for pedestrians who stepped off the trolley as well as those who came by bicycle or boat.

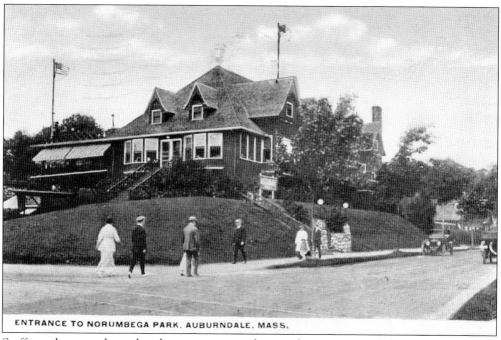

ENTRANCE TO NORUMBEGA PARK, AUBURNDALE, MASS.

Staff members stood guard at the entrance to make sure that patrons paid their admission to the park. As a marketing tactic, management packaged trolley fare with park admission. A round trip on the trolley cost 15¢; admission to the park cost 5¢ more. Those who did not take the trolley paid 10¢ for park admission.

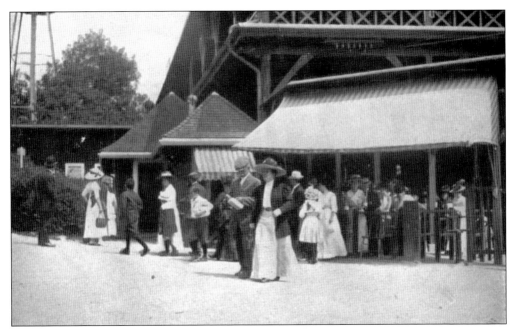

Norumbega Park proved a tremendous success right from the start. During its first summer, more than 160,000 people visited. The directors publicized their commitment to "the good order maintained" with a police force to keep the park "free from all objectionable characters." It was important that the park uphold its wholesome image, because some other prominent American amusement parks had a reputation for rowdiness and a honkytonk atmosphere. In the early 1890s, Coney Island in New York was nicknamed "Sodom-by-the-Sea." Other parks, including four in Milwaukee, were run by breweries to promote beer. These stood in contrast to Prohibition Park, a teetotaler's paradise, which opened in Staten Island in 1887.

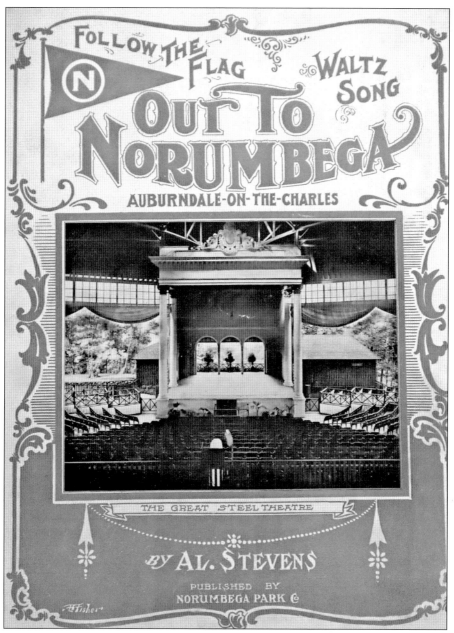

FOLLOW THE FLAG

WALTZ SONG

OUT TO NORUMBEGA

AUBURNDALE-ON-THE-CHARLES

THE GREAT STEEL THEATRE

BY AL. STEVENS

PUBLISHED BY
NORUMBEGA PARK Co

"Out to Norumbega," a popular song composed in 1906 by Al Stevens, was dedicated to Carl Alberte, who managed Norumbega Park for more than 20 years. The lyrics begin, "There's a beautiful place to go, where the Charles River breezes blow. It's not very far, take a Boulevard car." The chorus goes, "Out to Norumbega by the winding river's side, It's in the Garden City and it's everybody's pride." Two other Boston-area parks, Paragon Park at Nantasket Beach and Wonderland Park at Revere Beach, were similarly honored with musical themes. Under Alberte's leadership, the park increased in size from 10 to 25 acres and set new attendance records and increased profits almost every year. Alberte also cleverly extended revenue beyond the official season from Memorial Day through mid-September by opening the zoo and boat rentals and by renting the grounds to large groups in the spring and fall.

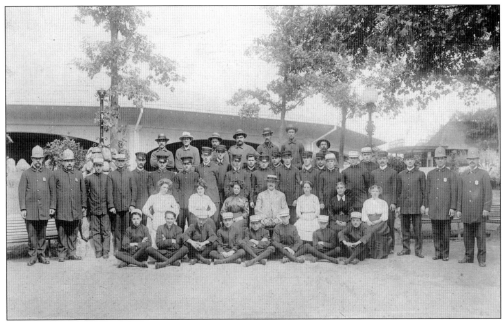

Many of the workers at Norumbega Park lived in Newton. They ran the restaurant, supervised concessions and rides, and cleaned up. This photograph from 1897, the park's first season, shows only six women. In later years, more women were hired, though all the owners and managers throughout the years were men, reflecting common management practices through the mid-20th century.

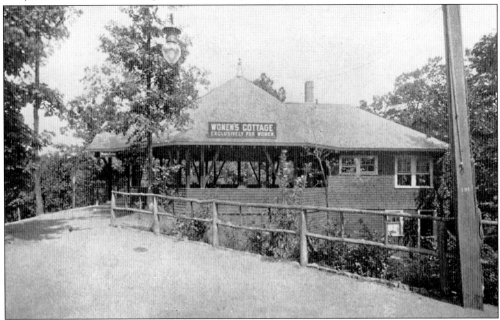

The Women's Cottage, staffed by a matron, helped females feel comfortable visiting the park without a male escort. An 1899 promotional brochure noted that no men were allowed to enter "under any pretext." The octagon-shaped pavilion included toilets as well as marble washbasins. Beds for children, cots, and rocking chairs made it easy for families to rest in between visiting park attractions. The cottage was later nicknamed "Mothers' Rest."

Two

DOWN BY THE RIVERSIDE

Norumbega Park's location next to the Charles River placed it within an already popular recreational area, creating synergies between the park and other attractions. The park occupied the midpoint of the approximately six-mile "Lakes District" on the Charles River. This area of relatively calm water was created when the Boston Manufacturing Company completed a dam at Moody Street in Waltham in 1815. The dam raised the water level in the river between its location and the waterfalls at Newton Lower Falls.

Many writers praised the area's natural beauty. "The view is charming beyond description," wrote Elizabeth G. Shepard in *A Guide Book to Norumbega and Vineland* (1893). "The gently undulating country, the trees with their varying foliage and the river flowing by, reflecting the loveliness of shores and sky." M.F. Sweetser, author of the *King's Handbook of Newton* (1889), wrote, "It is to be doubted whether any other large city in the civilized world has, within easy access to its heated human masses, a reach of river at once so attractive and so quiet as the Charles River between Waltham and Newton Lower Falls . . . without rival anywhere for pleasure-boating purposes."

Steamboat service on the upper Charles River began in 1873, with three daily trips between Waltham and Auburndale. In the 1880s and 1890s, canoes and other pleasure boats crowded the river in pleasant weather. Around 1900, approximately 5,000 canoes were stored in boathouses along the Lakes District. That was enough to line up bow to stern from Newton Lower Falls to Moody Street and back again, a distance of 17 miles.

Boating remained a primary form of recreation near Norumbega Park until the early 1930s, when an increasing number of people began to take automobile drives for fun. Even though the Charles River became too polluted for swimming in the 1950s, Norumbega Park continued to advertise its riverside setting and to rent boats until the park closed.

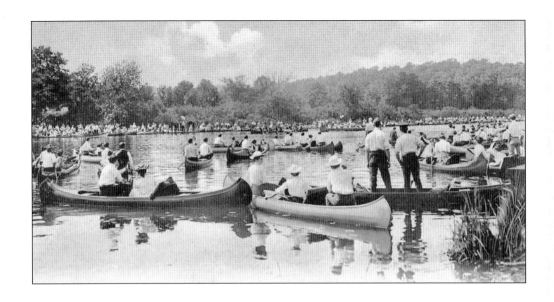

Boaters liked to congregate near the Weston Bridge connecting Newton and Weston, and spectators enjoyed watching. Around 1900, a young man's first major purchase was likely to be a canoe. This kind of boat combined elements of recreation, exercise, competition, transportation, and independence. To keep up with demand, boatbuilding facilities including Robertson's and Emerson's opened in Auburndale. Robertson's also built a steam-powered racing car for the Stanley brothers, Newton residents who invented the steam-powered Stanley Steamer. The car set records in 1906 but crashed in 1907, and another was never built. The first swan boats for the Boston Public Garden were built at Partelow's boathouse.

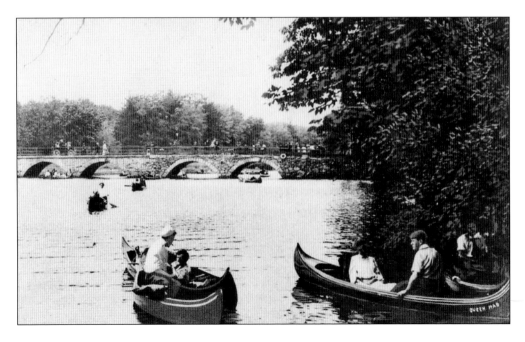

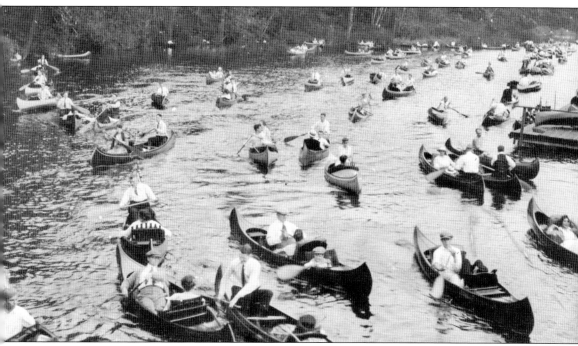

Many canoe owners named their boats and outfitted them to be comfortable for long outings. Bob Roy, who worked at Norumbega Park in 1950, remembered,

Our canoeing accessories included a mattress to kneel on and three or four matched pillows. There would be a canopy to keep the sun off your passenger, and a mosquito net for the evenings. The paddles were painted with fancy designs or the owner's initials. The ideal, or at least the most impressive way to paddle, was to keel the boat over so that the water was right at the gunwale. Then you could paddle without ever taking your paddle out of the water, and always staying on the same side of the boat. If you were good at it, and most of the Auburndale kids were, you could maneuver the canoe in any direction.

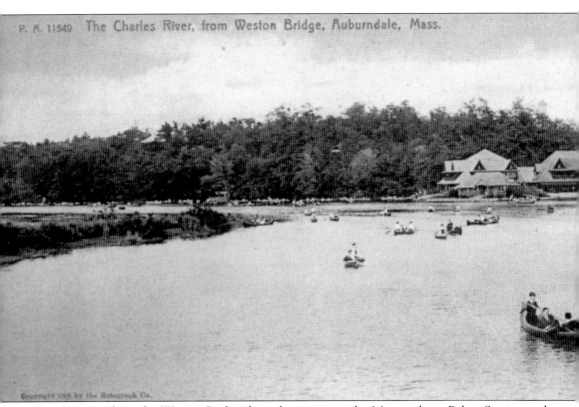

P. A. 11549　The Charles River, from Weston Bridge, Auburndale, Mass.

Copyright 1905 by the Rotograph Co.

This view from the Weston Bridge shows boaters near the Metropolitan Police Station and Norumbega Park. This image originally appeared on a postcard. The first picture postcards, called "postals," began to be published around 1893. At the time, the idea that anyone would spend money for a picture of an attraction, then spend more money to mail this promotional material

24

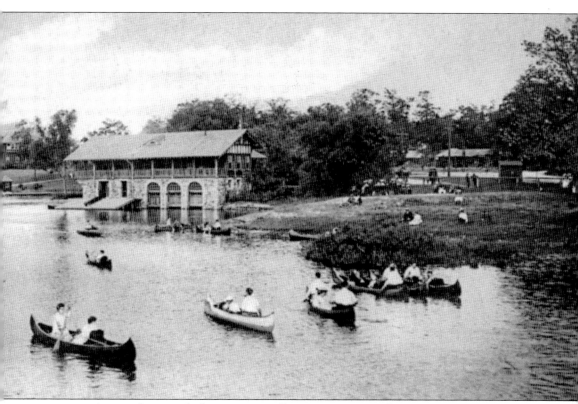

to someone else, revolutionized advertising as well as communication between friends and family members. Vendors profited, too. A thousand color postcards that sold wholesale for $5 could be retailed for a penny each, giving the retailer a gross profit of 100 percent.

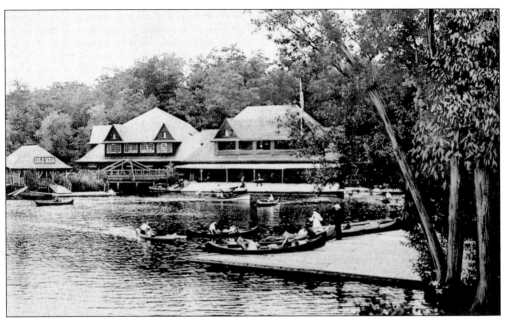

Many patrons traveled to Norumbega Park by boat. The boat livery on the premises allowed canoes and rowboats to dock for free when the boaters visited the park. Norumbega Park also rented canoes and rowboats to patrons who wanted to make a recreational boat ride part of their day or evening at the park.

Trails in the park went alongside the river and down to the boathouses. The park's first manager, Carl Alberte, in an article in *Street Railway Journal* on May 5, 1900, described "quite a large amount of water frontage," adding "the park land is not all tame, but undulating in character."

Boat rentals were in high demand during special events on the river. In 1904, a river carnival took place during Labor Day weekend. The lead vessel in a floating parade was themed "Cleopatra's Barge, Greeting to Antony, 40 B.C." Other boats interpreted "The Flag Our Fathers Saved," "The Minute Men of '98," and "A Red Cross Field Hospital."

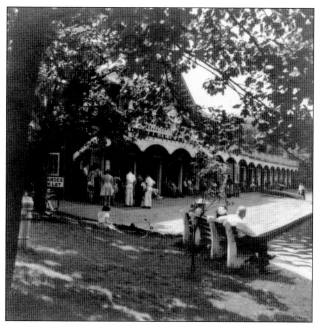

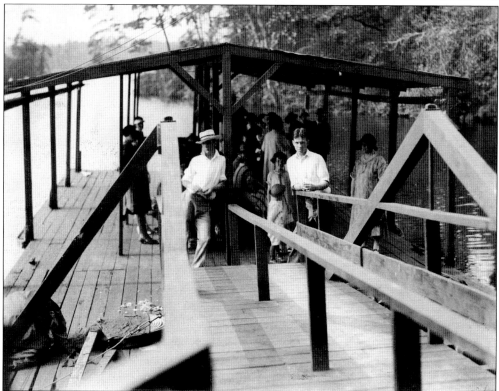

Benches underneath a simple roof gave passengers a shaded, comfortable place to wait for an excursion boat. Most trips took place without incident, but on July 16, 1950, an excursion boat named the *Swan* became disabled off Norumbega Tower. A rescue boat had to make three trips to pick up all the passengers. Then the boat towed the *Swan* back to Norumbega.

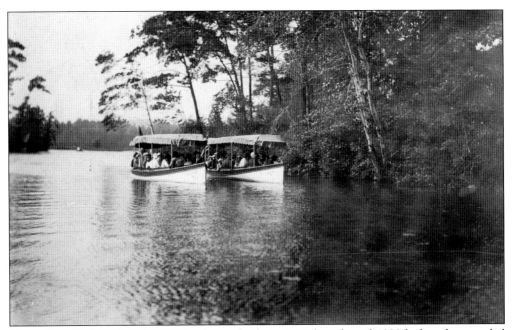

Norumbega Park's original excursion boats, built in 1898, lasted until 1923 before they needed refitting. The refurbished boats, named *Josephine* and *Velma*, took customers up and down the river near the park. These boats were for park patrons only. For others simply in search of a ride, private boat companies on the upper Charles River took passengers for rides between Waltham and Newton. In the 1890s, one destination along the river in Waltham was Forest Grove Park, which provided a dance hall, a carousel, a refreshment stand, and swimming. Around the same time, Echo Bridge Park in Newton Upper Falls also operated a carousel and music stand. Competition from Norumbega Park proved too strong for either park to survive.

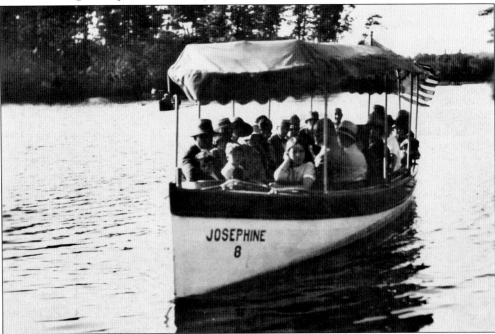

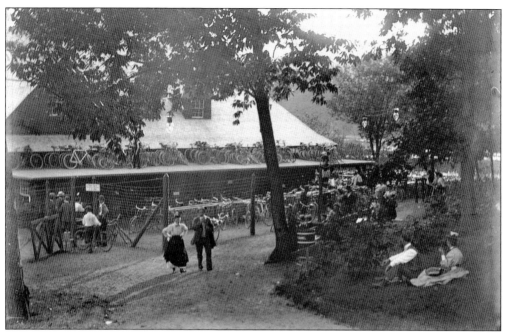

In the late 19th century, bicycling exploded in popularity in America, and Boston became a center for the sport. New safety bicycles, more stable than bikes with oversized front wheels, attracted legions of male and female riders. Cyclists from Boston frequently rode to the Chestnut Hill Reservoir or stopped at the Woodland Park Hotel in Auburndale. Norumbega Park became another popular destination. While visiting the park, cyclists could check their bikes for free at the storage shed, otherwise known as the "bicycle yard." The yard boasted room for over 1,000 bikes and sometimes handled over twice that number. When storage on the ground filled up, spots could be found on the roof.

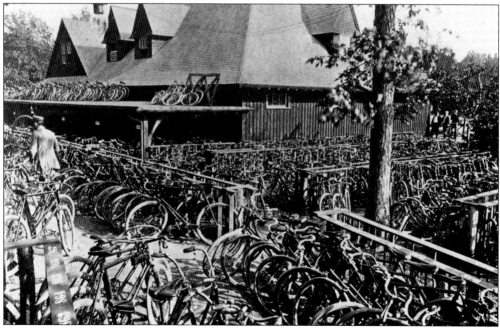

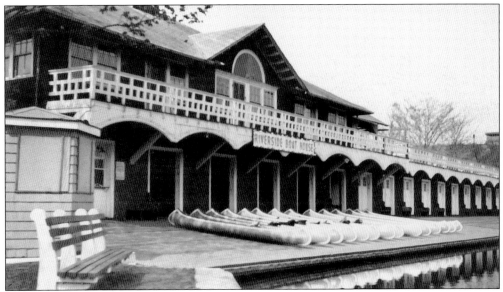

The Riverside Recreation Grounds, known as the "Rec," opened just a few months after Norumbega Park. While Norumbega held concerts at its bandstand, a musical barge was often towed on summer nights between the Riverside Boat House and the Nuttings facility downriver in Waltham. One or two bands played music on the barge, while a flotilla of canoes trailed behind so paddlers could listen.

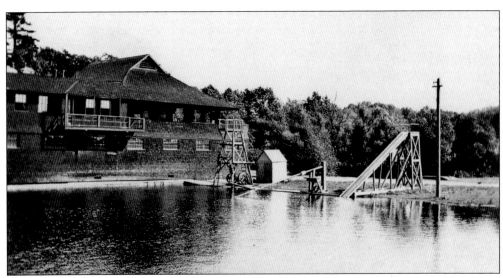

Funded by Weston businessman Charles W. Hubbard, the Riverside Recreation Grounds included a swimming pool as well as a track and playing fields. Its canoe rentals and restaurant competed with Norumbega Park, but the Rec emphasized physical fitness, not amusements. The banks of the Charles River attracted other ventures. Nearby, the Boston Athletic Association owned a boathouse and playing fields purchased by Boston University in 1930.

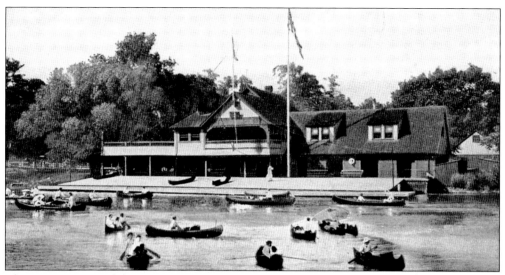

The Newton Boat Club was one of many boathouses that lined the banks of the Charles River from Newton into Waltham. A new canoe typically cost between $30 and $60 depending on the style and grade of wood. The craftsmanship from these local boathouses was generally so sound that people still used the boats more than 50 years after they were built.

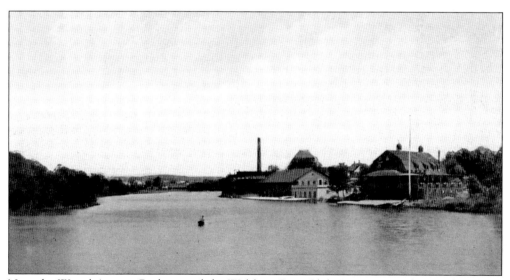

Near the Woerd Avenue Bridge stood the Waltham Boat Club. In 1907, members of the nearby Woerd Avenue Canoe Club set the fastest time ever recorded paddling a war canoe for a mile: 5 minutes and 21 seconds. A fierce competitor, the Wawbewawa Canoe Club in Auburndale, consistently won singles, doubles, fours, and giant nine-man war canoe races across New England over more than 20 years.

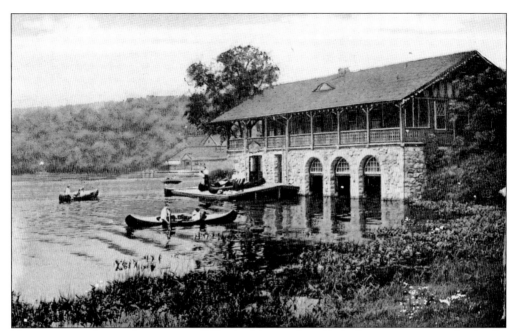

To maintain order on the water, in 1903, the Metropolitan Park Commission created rules for people using the river, prohibiting profanity, liquor, "loud outcry," fireworks, and littering. This police station and boathouse opened in 1904. Along with jail cells, it contained wringers and a drying room for the clothing of capsized boaters. A darkroom was used for developing photographs taken by police as evidence of "disorderly proceedings" along the river.

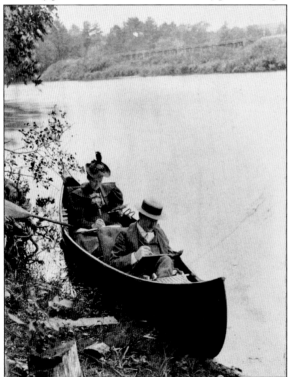

After residents who lived along the Charles River began complaining about couples who pulled their canoes into secluded inlets for romantic interludes, the Metropolitan Park Commission police began enforcing rules that forbade couples from kissing and from lying down in canoes. Police arrested a couple for kissing on August 15, 1903, and the man received a $20 fine. Uproar ensued, but strict enforcement continued until around 1906.

In 1924, the women's national 880-yard swimming race took place for the first time in the Charles River at Norumbega Park. Gertrude Ederle (in hat), an Olympic swimmer, won first place. Ederle went on to become the first woman to swim the English Channel, completing the 21-mile crossing from France to England in 1926.

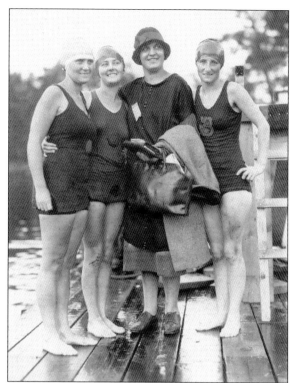

A women's swimming race was held in the Charles River at Norumbega for several more years after its debut in 1924. In 1950, the river closed for swimming due to pollution. Today, even though many manufacturing facilities along the river have closed, the river is still generally considered unsafe for swimming, as water quality fluctuates according to levels of rain and stormwater runoff.

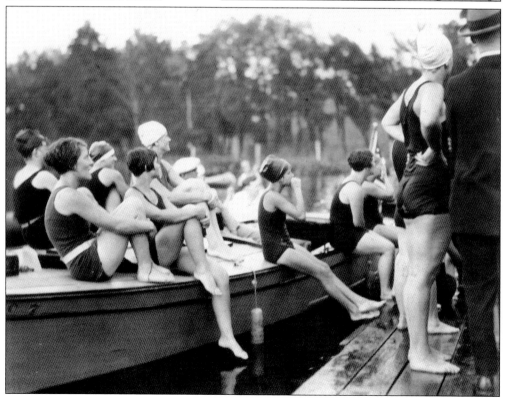

Visitors to Norumbega Park often came down to the water's edge to watch swimming races and other activities in the river. It was part of the entertainment. "Whenever the river is crowded . . . the paths along the shore will all be quietly animated with philosophic idlers," wrote Arthur Stanwood Pier in *Outing Magazine* in August 1908.

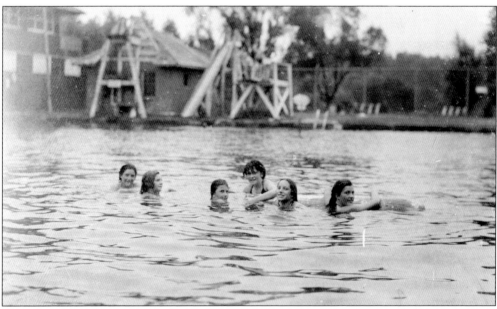

The Riverside Recreation Grounds were originally intended to give young men from Boston access to recreational facilities outside the city, tying into the 19th-century belief in the health benefits of parks and fresh air. The facility also became a popular destination for Newtonians. Along with the pool, there were bowling alleys, an outdoor gymnasium, and dormitories.

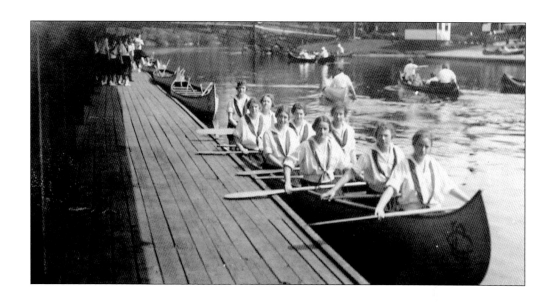

Lasell Seminary (now Lasell University) sent several student crews to race in the annual River Day at the Charles River in 1920. The school, founded in 1851 as the Auburndale Female Seminary, was the first two-year college for women in the United States. It was named after its founder, Edward Lasell, a professor of chemistry at Williams College. It is not clear when sports became part of the extracurriculars, but the school did regularly participate in the annual River Day in the early 20th century. River festivals and boat parades helped bring people to Norumbega Park for spectating.

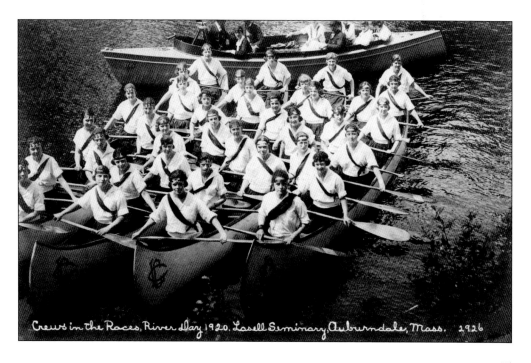

Crews in the Races, River Day 1920. Lasell Seminary, Auburndale, Mass. 2926

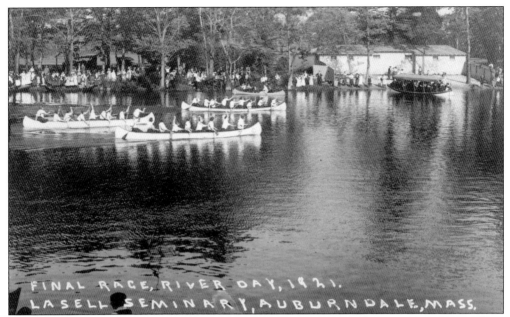

FINAL RACE, RIVER DAY, 1921.
LASELL SEMINARY, AUBURNDALE, MASS.

Lasell College sent several teams to river races in 1921. The high point for boating near Norumbega Park came in 1920, when on Memorial Day the Metropolitan Police estimated that there were more than 6,000 small boats in the Lakes District of the Charles River. One of the last major regattas held on the upper Charles River took place in 1950.

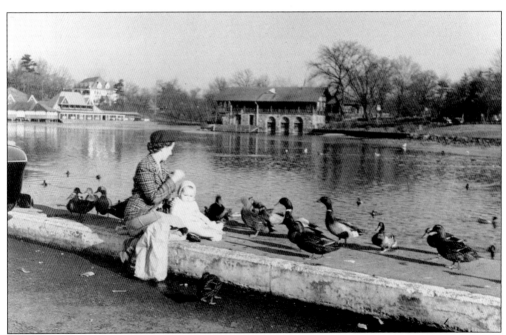

By the 1940s, when this photograph was taken, this riverbank opposite Norumbega Park had become a popular place for duck feeding. At night, the parking lot often turned into a lover's lane for young people. Though Norumbega Park continued renting canoes and added pedal boats to its fleet in the 1940s, by the 1950s, it had converted one boathouse into an amusement ride.

Three

AMUSEMENTS FOR ALL

From the outset, Norumbega Park emphasized family fun. The park's original 12-acre grounds eventually expanded to approximately 25 acres through land purchases and filling in the river. In 1899, park president Adams Claflin, treasurer Leonard Ahl, and manager Carl Alberte toured amusement parks around the United States to come up with ideas for improving Norumbega Park, setting the precedent for subsequent years of new or revamped attractions to keep repeat customers interested. The directors also made maintenance a priority, creating the park's long-lived reputation for cleanliness and beauty. "The management takes special pains to ensure safety and comfort of visitors," wrote manager Carl Alberte in a 1900 article, adding that the park had not experienced an accident since it opened in 1897.

The sprawling grounds gave planners room for a variety of activities. While the vaudeville shows and rides required a ticket, attractions included in general admission lined the park. In the early days, the Electric Fountain, powered by the same source that ran the trolleys, presented some 200 different combinations of geysers, cascades, and fan sprays of "grand and bewildering effects," according to a promotional brochure. The Zoological Garden, one of the largest in the United States, boasted 150 species, with new animals added almost every year in the park's first 20 years. Advertisements touted its "most complete collection of animals in the country," a novelty at a time when few people had the means to travel to see leopards, monkeys, and other exotic fauna.

Picnic grounds and playing fields, which included a baseball diamond, brought in many community, civic, and business groups for outings. In the 1920s, the Corpus Christi team in the Newton Amateur Twilight League used the baseball field for its home games. A female softball team, the Totem Pole Belles, played in the 1940s.

Throughout the years, people visited for a day's outing at a moderate cost. Whether they came for the shows, the rides, or a boat rental, the tree-lined pathways and cool breezes in the days before air conditioning usually provided a pleasant escape from the city.

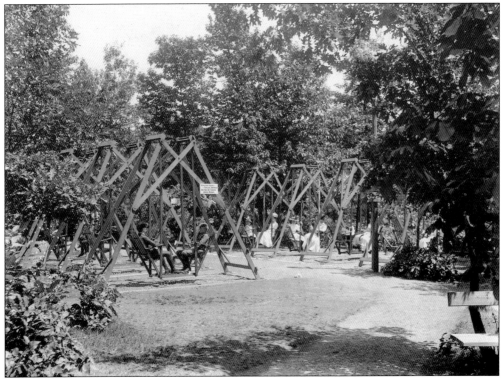

For 60 years, the wooden swings at the Swing Court offered a basic amenity, giving everyone a chance to take a break from the noisier and more active areas of the park. In the early days, women and children were encouraged to relax here, because the area was supervised to keep it free of loiterers.

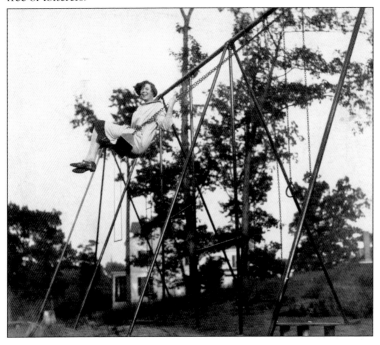

As Norumbega Park acquired more property, there was room to add new features, including playground equipment. These swings provided a more exciting ride than the tame wooden swings in the Swing Court, which primarily rocked back and forth and couldn't reach great heights. Young people who were inspired by the acrobatic acts also enjoyed the chance to try the rings and trapeze bar.

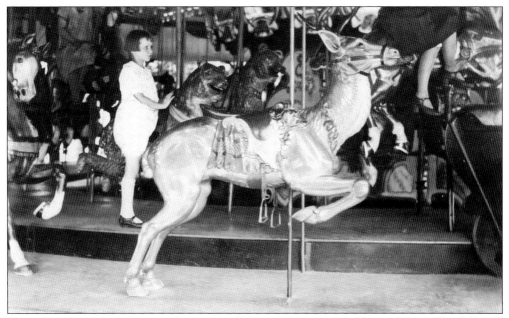

Norumbega's carousel was manufactured by the Dentzel Company of Pennsylvania. The 52 hand-carved animals included horses, tigers, cats, deer, and several other species. Power came from the same source that ran the electric trolleys. In 1914, six tickets sold for 25¢, and the typical ride lasted five minutes. A Wurlitzer band organ arrived in 1925 to provide the music.

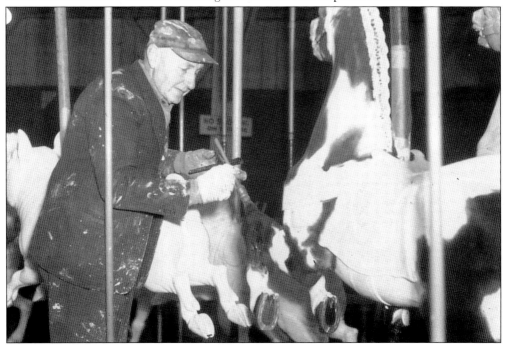

Albert Busch, a skilled mechanic, came to work at Norumbega in 1926 and stayed for the rest of his life. Living on the grounds, he maintained the rides and gave the carousel animals fresh coats of paint. In 1961, at age 75, he was struck by a car outside the park and died from his injuries. The park closed early two nights in a row to honor Busch's memory.

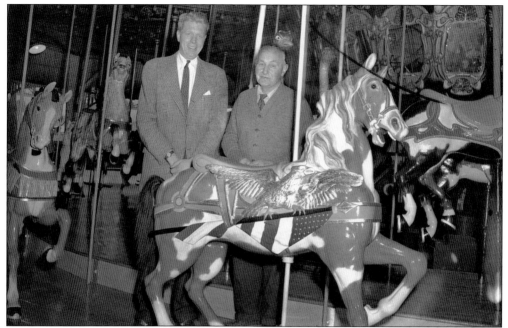

The park's owner in the 1950s, Doug Farrington (left), worked closely with Albert Busch. The carousel continued to operate until the park closed in 1963. Red Canty, an employee, was ordered to destroy the carousel after the closing, but he ended up removing the wooden animals and storing them in his basement. A music enthusiast from the community rescued the Wurlitzer organ. Now the carousel animals and the organ have become collectors' items.

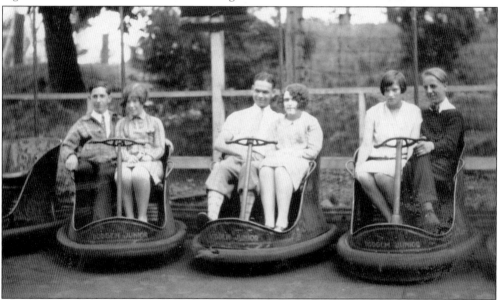

The Dodgem, the brand name for the nation's first bumper car, was patented in 1921 by Max and Harold Stoehrer, brothers from Methuen, Massachusetts. Powered by electricity and open in front, the cars gave patrons a taste of driving. Norumbega's earliest cars were built at Witham Body Company in Amesbury. The design was later changed to more closely resemble the automobile and improve safety.

Installed at Norumbega Park in 1927, Custer Cars resembled the Dodgems but traveled around a wooden track. Many other amusement parks around the country, including Hershey Park in Pennsylvania, offered Custer Car rides, a low-stakes way for people to get behind the wheel—a new experience for many at the time. Inventor Levitt Luzern Custer built the amusement park cars at the Custer Specialty Company of Dayton, Ohio. Powered by a battery, the park car could go around any track. A later model powered by gasoline went on the road. Custer also invented a paddle boat that passengers propelled by using foot pedals, an addition to Norumbega Park in the 1940s.

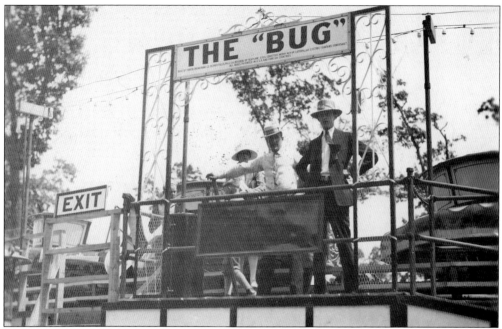

The Tumble Bug, or Bug for short, arrived at Norumbega Park in 1927. Built by the Traver Engineering company in Beaver Falls, Pennsylvania, the Bug traveled around a hilly, circular track. The name came from the insect motif on the exterior of the cars. A variation of this ride used cars painted to resemble turtles. Soon after the Bug's installation at Norumbega, a group of Auburndale residents contacted the Newton Board of Aldermen to protest the noisy amusement machines and new rides, specifically the Tumble Bug and the Hey-Day. According to the *Newton Graphic*, several aldermen visited the park to assess whether "screeching" from ride-goers was a problem and determined that no action was necessary. One alderman pointed out that roaring lions made more noise than the rides.

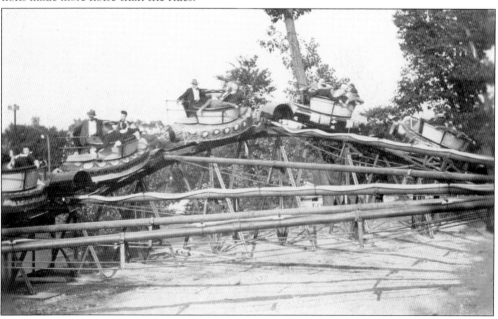

In 1928, Norumbega Park applied to the City of Newton for permission to add a Ferris wheel to the park. An engineer tested the equipment to certify its safety. Installed in time for the 1928 season, the Ferris wheel, 70 feet high, was promoted as the largest in New England. The ride was named after its inventor, George Washington Gale Ferris Jr., and was launched in Chicago in 1893.

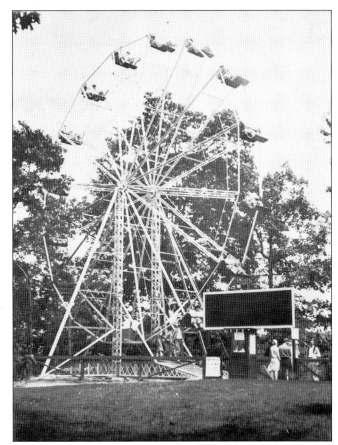

Norumbega's Ferris wheel shut down after it sustained damage in the hurricane of 1938. Though mechanics tried to repair it, Newton city engineers were never satisfied with the work and refused to issue a permit for the ride to reopen. New games along the midway filled in the spot where the Ferris wheel had once stood.

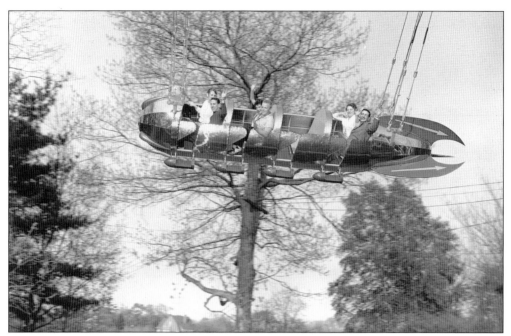

Before NASA launched rockets into space, the Rocket ride entertained parkgoers at Norumbega. Each car, made of a metal frame, swung out from a chain as the ride spun, giving people the sensation of flying. Diana Levy, who grew up in Auburndale in the 1950s, remembered the rides from family outings: "Mom played Bingo with her sisters while the dads took us kids for rides."

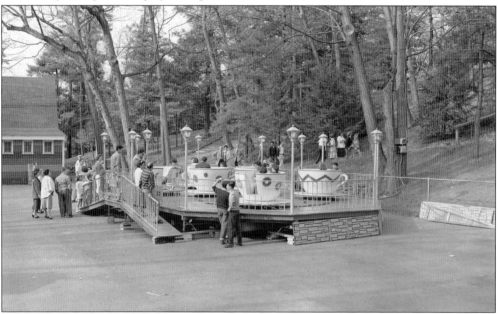

The Crazy Cups ride spun people in two ways: around a track and inside the cup itself. Woe to anyone with a weak stomach! In 1955, Disneyland was one of the first parks to offer this type of ride, designed by California-based Arrow Development. Similar rides became standard at amusement parks, including Canobie Lake Park in New Hampshire. Norumbega Park installed its ride in the 1950s.

Kiddieland opened at Norumbega in 1947, replacing a miniature golf course. The amusements were designed to appeal to young children of the postwar baby boom: automobiles, fighter planes, and an old-fashioned horse-and-buggy ride. Tickets to Kiddieland initially cost 9¢ each. Many patrons of Kiddieland returned to visit the Totem Pole Ballroom when they grew older.

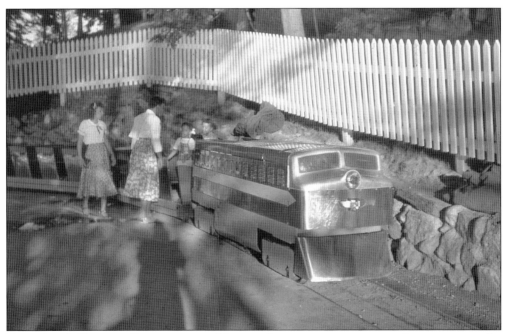

Norumbega's Tinytown Express, powered by a working steam engine, was a favorite among the young visitors in the 1930s. Patrons boarded behind the boathouse. The train went north along the river and looped around Monkey Island. This train and tracks were removed during World War II. A gas-driven train that did not need tracks replaced it.

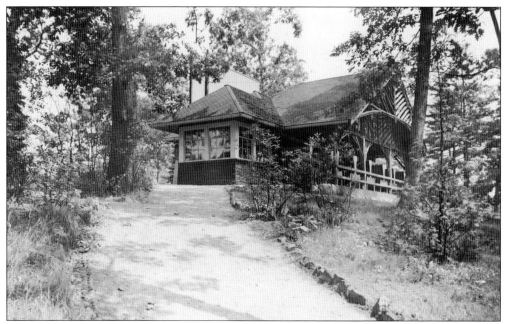

Most of the coin-operated amusements were inside a building at the north end of the park, originally called the Chalet. Among the most popular was the Mutoscope, which created motion pictures when patrons turned a crank to make pictures flicker past. The Chalet was later renamed the Squintorium (1930s) and Pennyland (1940s). The area was informally called the Penny Arcade.

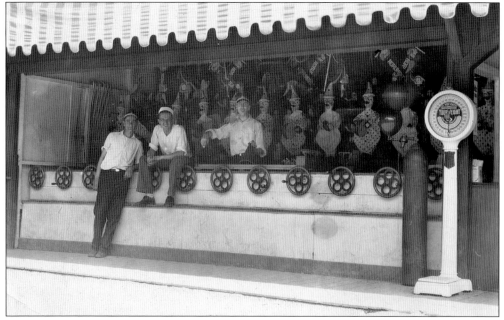

Norumbega added games, such as this one with clowns as targets, to booths along a midway near the carousel. Bob Pollack, who worked at the park in 1957, wrote, "The greyhound race and the basketball pitch were considered status games, and were always operated by older boys who had worked at Norumbega for several summers." As a newcomer, Pollack ran a dart balloon game and suffered many injuries from errant darts.

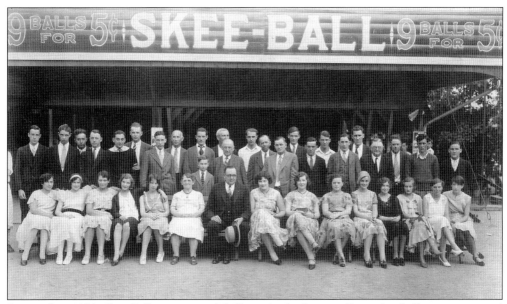

Patented in 1908, Skee-Ball is a game of skill in which players roll wooden balls up a ramp and try to sink them into a series of holes. It caught on around the country, especially in Atlantic City, which opened a Skee-Ball stadium. At Norumbega Park in the 1920s, Skee-Ball bowlers got nine balls for 5¢. The popular booth made a colorful backdrop for a park staff photograph in 1932 (above). At center, holding his hat, is Arch Clair, manager of Norumbega Park from 1930 through 1937. The game of Skee-Ball didn't change much over the years, but other midway games at Norumbega were modified to reflect life outside the park. During World War II in the early 1940s, metal bottles that were the target of a ball-tossing game were replaced with caricatures of Hitler, Tojo, and Mussolini. After that, people threw the balls at fuzzy cats.

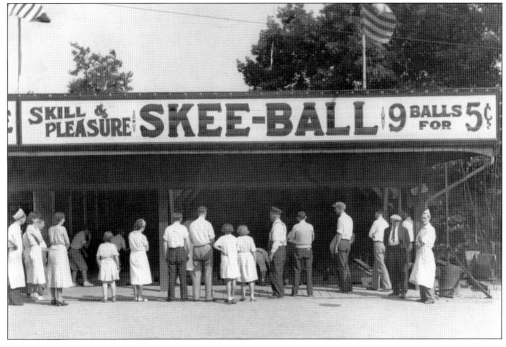

Games rewarded high scorers with prizes including kewpie dolls, straw hats, and Norumbega pennants. During the Great Depression in the 1930s, prizes changed to more useful items, including bags of flour, coffee, and sugar. Unlike some other parks, Norumbega discouraged high-pressure barkers. The City of Newton also required games of skill to be licensed. Tom Haldoupis, who grew up in Roslindale and visited Norumbega Park as a child, remembered the "great" prize booth. "Numerous strings would hang—all attached to wonderful prizes that were in plain view. For a price you could pull a string and hope that the prize you were aiming for would be on the other end." The games and prizes proved popular with the Totem Pole Ballroom crowd, too. Many couples often walked down to the arcade while the band took a break.

Norumbega Park advertised its zoo as one of its main attractions. It was one of more than a dozen American zoos that opened around the beginning of the 20th century. The first American zoological garden opened in Philadelphia in 1874. These early institutions showed a variety of exotic animals to nonscientists and helped urban dwellers experience the natural world.

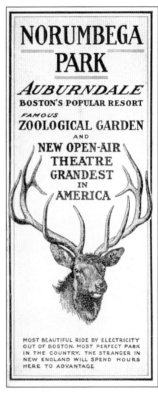

Norumbega Park's Zoological Garden advertised "animals in natural enclosures," not in cages. Between 1903 and 1919, John Benson ran the zoos at Norumbega and its sister park, Lexington Park. In 1920, Benson left to focus on his career as an animal expert. He went on to found Benson's Wild Animal Farm in Hudson, New Hampshire.

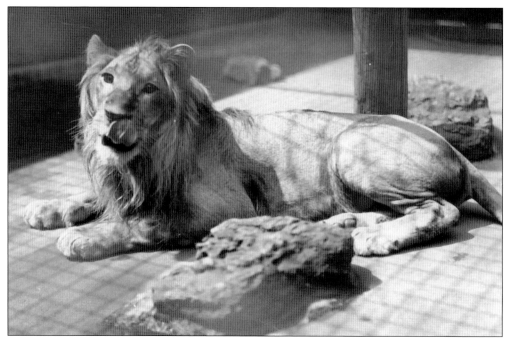

In the 19th century, lions and other big cats appeared in traveling shows and menageries as well as in zoos. These exotic animals appealed to visitors, but they could occasionally prove dangerous for staff to handle. Norumbega's zoo animals spent the winter in Havana, Cuba, and returned to the park in the spring. In December 1909, as workers transferred the animals to cages for transport, a leopard attacked and mauled one of the workers. Park manager Carl Alberte shot the leopard dead. The man recovered. Other animals occasionally escaped to Islington Road, a residential area near the park, and had to be recaptured.

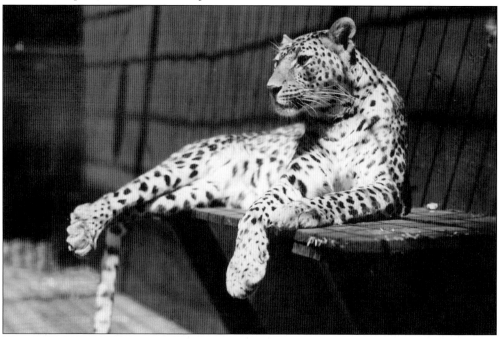

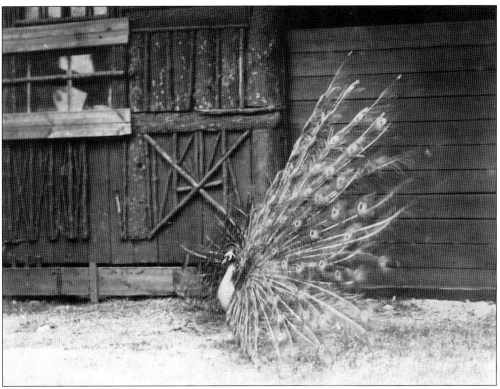

With their colorful, iridescent feathers, peacocks, also called peafowl, always attracted attention at Norumbega Park's zoo. These exotic birds, part of the pheasant family, are native to India or Indonesia. Many zoos in the United States kept peafowl. In the early 20th century, they used to wander around the grounds of the National Zoo in Washington, DC.

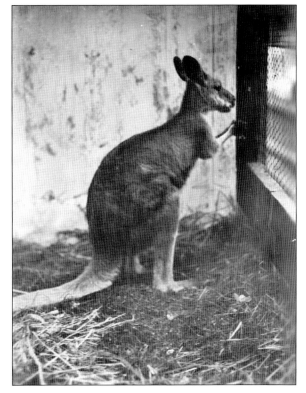

Native to Australia, kangaroos seemed particularly exotic in the early 20th century. The San Diego Zoo in the 1920s became one of the first American institutions to house live kangaroos. Because these animals can sometimes jump three times their own height, they lived in a secure enclosure at Norumbega Park.

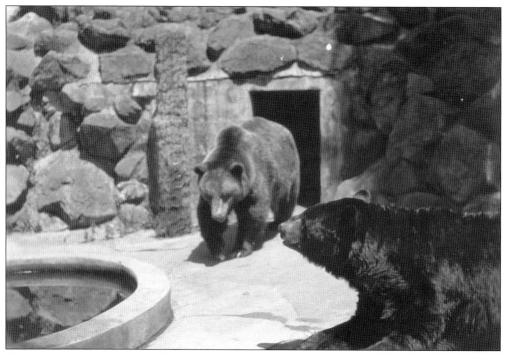

The bear den, completed in 1899, was advertised as the largest bear enclosure in New England. Its first inhabitant, Jack, received a bride, Jill, soon after his arrival. The bears drew visitors inside and outside of the park. A 1908 article in *Outing Magazine* noted, "The big bear at Norumbega Park is more successful than any peripatetic preacher" in holding the interest of canoeists. In 1924, the park held a contest to name new bear cubs. The names chosen were Ned, Nick, and Nora. Norumbega's zoo closed in 1942, because the year-round care and feeding of the animals became too expensive. Only the bears were retained so the park could continue to advertise live animals as an attraction.

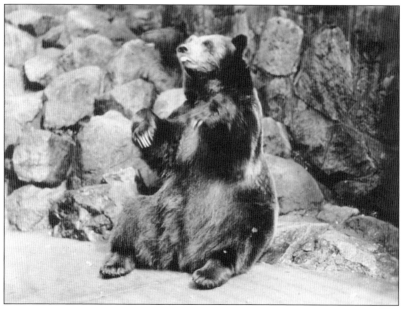

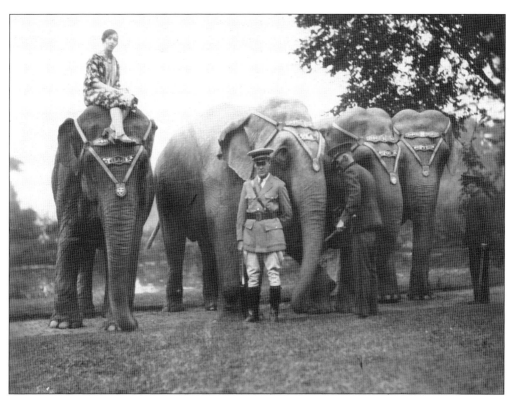

The Robinson Traveling Circus presented elephant shows in the Great Steel Theatre at Norumbega for over 30 years. From left to right, the elephants Tillie, Clara, Tony, and Pit appear with their keeper Dan Noonan. Along with caring for the elephants during the summer, Noonan traveled with them to their winter quarters in Terrance Park, Ohio.

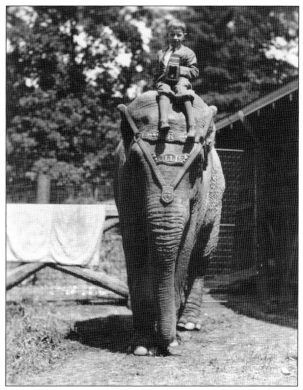

Tillie the elephant was the star of the Robinson Circus. She began performing in 1872 and eventually led the act. A favorite among the staff at Norumbega Park, she was gentle enough to give rides to children. Howard Hawes, son of park photographer William Hawes, takes a turn on Tillie in this image.

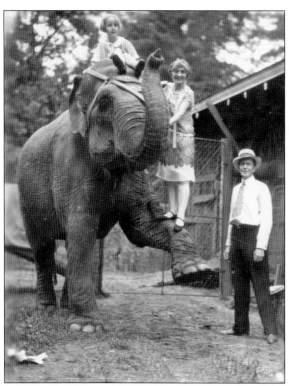

Betty White, daughter of park manager William White, rides Tillie as White and his wife, Dorothy, accompany her. So widespread was Tillie's fame that over 2,000 people attended her funeral service at circus headquarters in Terrance Park, Ohio, when she died in 1932. Some people claimed that she lived to be 120 years old, but a more realistic assessment puts her age closer to 60.

A park patron rides Eva, another performing elephant. The Robinson Traveling Circus, a family business, began in the 1840s. Their most famous act involved "military" elephants firing cannons and maneuvering in formation. In 1916, they sold much of their circus to a company that later became Ringling Brothers.

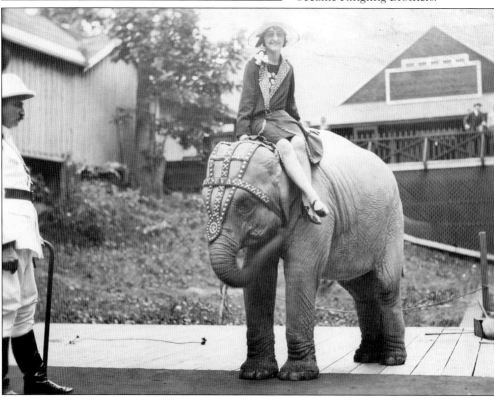

In 1931, the park acquired several rare monkeys, including a bonnet monkey, an African green monkey, and a redheaded mangabey. A separate enclosure named Monkey Island was built to accommodate them. In the late 1950s and early 1960s, so many monkeys bit attendants cleaning their cages that the emergency room staff at nearby Newton-Wellesley Hospital considered printing up a form for reporting monkey injuries.

In 1936, the newborn monkey Java proved to be a popular attraction. This mother-and-child pair may have arrived as part of the Bryan Woods Monkey Circus, a traveling show. Not all monkeys were as cute. In 1941, a few escaped the zoo and raided garbage cans at nearby houses. Newton police ended up shooting the animals because they frightened residents and repeatedly evaded capture.

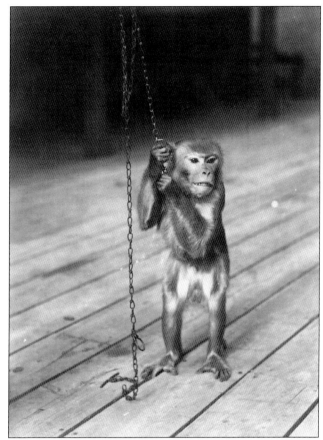

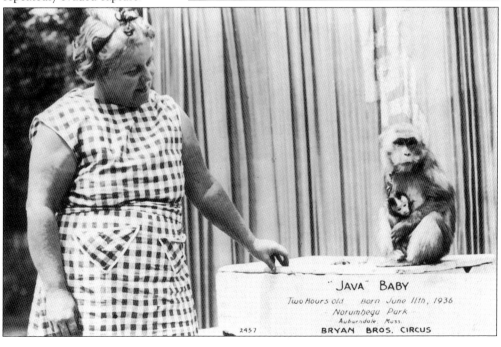

"Java" Baby
Two Hours old Born June 11th, 1936
Norumbega Park
Auburndale, Mass.
2457 BRYAN BROS. CIRCUS

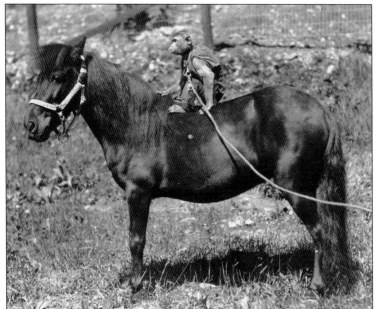

Some of the monkeys who came to Norumbega, such as the one seen here on a pony, were trained to perform tricks. Trained monkeys have a long tradition as part of carnival amusements. Though a show might seem like the origin of the phrase "not my circus, not my monkeys," this is a Polish folk saying that means "not my problem."

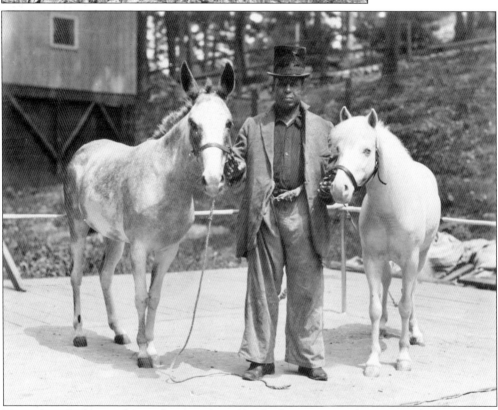

Norumbega Park owned several ponies that offered rides. James Washington worked at the park to feed and care for the ponies, making sure they were well groomed and had the right kind of disposition to allow children to take rides. Staff handlers like Washington helped ensure the safety of children who perhaps had never before ridden a horse.

The park advertised its pony rides, perennially popular with children, in the early 1920s. A track was installed near the ballfield in 1927. At one time, the park also offered donkey and camel rides. The rides were just one way that the park catered to young visitors. Over the years, children were offered free or discounted admission to help bring families through the gates at Norumbega Park. Charity events also brought in children who otherwise would not have been able to afford the admission fee. In 1924, children were admitted free to compete against the Red, White, and Blue Kiddies, who were national swimming champions between ages five and 14.

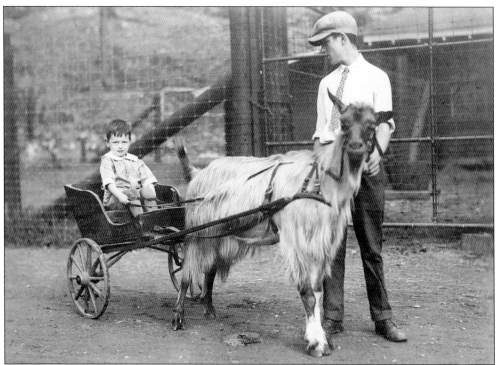

In 1923, the *Newton Graphic* previewed the Norumbega season: "especially arranged for children will be the donkeys to ride and the goats to drive." Though goat carts traditionally pulled wagons filled with produce or other farm products, traveling photographers often used them as a prop from the late 19th century into the 1930s, seating the child on a cart and taking a picture, then selling the print to the proud parents. The carts and children at Norumbega Park were certainly photogenic. A park employee walked with the goat to ensure that the ride went smoothly and the cart stayed upright.

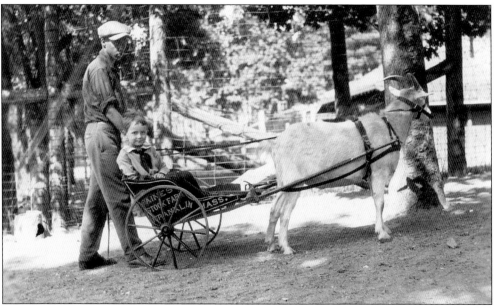

Four

THE SHOW MUST GO ON

Norumbega Park's architects took advantage of a natural amphitheater in the terrain when they built the original Rustic Theatre in 1897. The park's directors correctly predicted that vaudeville shows would attract large audiences that would also spend money in other parts of the park. Seating continually expanded to accommodate demand. The original theater, a roofed shed with sides open to the elements, seated approximately 2,000. In 1904, the theater added a 20,000-square-foot steel truss roof and expanded seating for 3,000. These renovations created one of the largest covered outdoor theaters in the United States. The sides remained open to better adhere to fire safety regulations. Safety was of particular concern because in 1903, a fire had destroyed the Iroquois Theatre in Chicago, claiming more than 600 lives.

Despite the precautions, in June 1909, a fire that started in the actors' dressing rooms destroyed the expanded theater. Its replacement, the Great Steel Theatre, designed to be fireproof, opened in 1910. Until the theater was enclosed in 1930 to create the Totem Pole Ballroom, this stage hosted a variety of entertainment, including musicians, plays with a resident troupe of performers, and films. The acts reflected trends in popular entertainment. Comedian Fred Allen appeared in 1914. A Newton-based trio of singers, the Garden City Three, performed in the 1920s. Organizer Joseph Antonelli grew up in the Nonantum village of Newton. Bob Emery, the host of the *Big Brother* children's radio show on Boston-area station WEEI, broadcast from the park in 1928. Scenes from the comedy *Our Gang* were filmed at Norumbega the same year.

Spectacles that did not fit onstage took place in the Hollow, a grassy area outside the theater. Live outdoor shows stopped in 1943, because park manager Roy Gill feared that a park patron would fall down the steep embankment surrounding the Hollow and be seriously injured.

Though shows constantly changed, the theater remained central to Norumbega Park. Performances took place in the theater and then in the Totem Pole Ballroom until it closed in 1964.

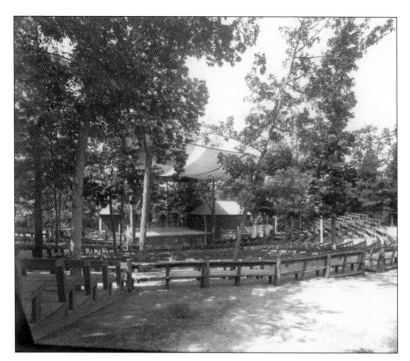

The park's original Rustic Theatre, located in a grove of shade trees, started as an outdoor stage with simply-constructed wooden benches surrounding it. The original plan included seats for 2,000 people, but benches added in 1901 increased the number to 2,700. A roof over the stage provided the only shelter from the elements.

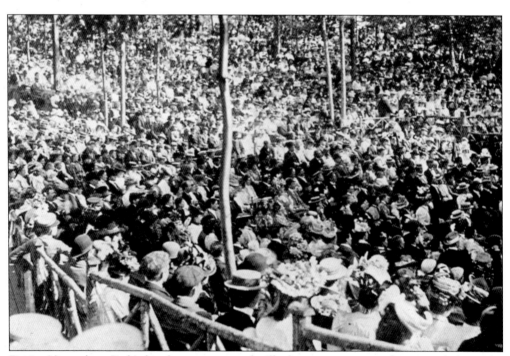

During Norumbega Park's first few seasons, vaudeville shows were presented twice each day at the Rustic Theatre, generally at 3:30 p.m. and 8:05 p.m. Evening and weekend performances usually attracted standing-room-only crowds. By 1909, seats could be reserved by calling the telephone exchange Newton West 227.

To protect Rustic Theatre patrons from rain and sun, the Norumbega Park directors in 1904 decided to add a 20,000-square-foot roof. The 1909 season was almost ruined when a fire damaged the building, but construction crews worked at a feverish pace to build a temporary structure in just 10 days. The new building opened on June 14, perhaps too hastily, as the park had to pay for the ruined dresses and trousers of customers who sat on the benches before the varnish had properly dried. Advertisements made the best of the situation, touting the "new, temporary theatre, a feat in modern mechanics."

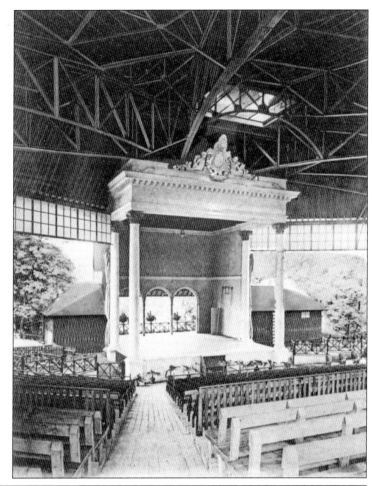

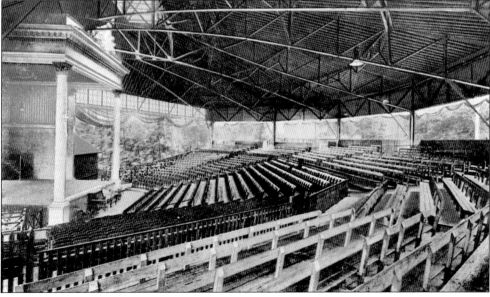

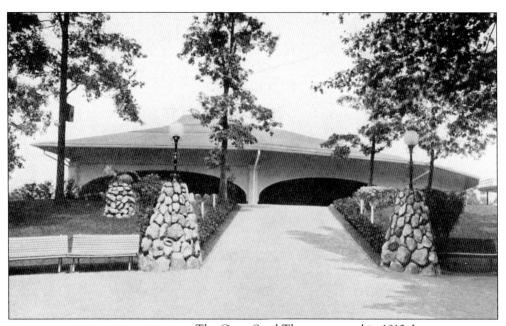

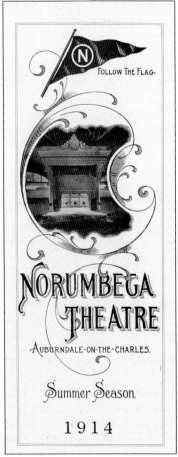

FOLLOW THE FLAG.

NORUMBEGA
THEATRE

AUBURNDALE-ON-THE-CHARLES.

Summer Season

1914

The Great Steel Theatre opened in 1910. It cost $60,000 and seated 3,500, making it the largest theater in New England. The *Newton Graphic* on May 27, 1910, called it "a magnificent structure" with details "artistically effective and pleasing to the eye." At its opening, Newton mayor Charles Hatfield praised Norumbega Park's directors for investing in the project and said citizens of Newton could take pride in it.

On the cover of this 1914 theater program book, "Follow the Flag" refers to a line from the popular 1906 song "Out to Norumbega" by Al Stevens: "When you're feeling blue, then there's one thing to do. Just follow the flag and be gay." Trolleys that went along Commonwealth Avenue flew a blue pennant emblazoned with a white *N* to advertise their destination.

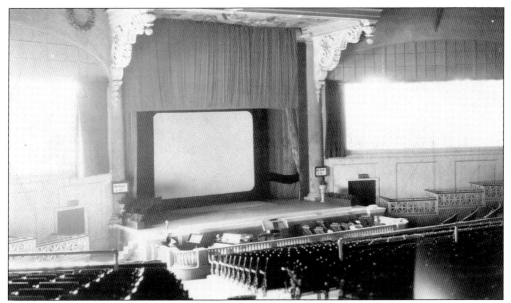

Shows in the early part of the 20th century ended with Komograph movies shown on this screen. Later, the films changed to silent motion pictures with stars including Charlie Chaplin and Douglas Fairbanks. In the 1920s, fireworks displays took place after the Friday night movies. On Sunday mornings, when blue laws restricted entertainment, the theater hosted free religious concerts with the Boston YMCA.

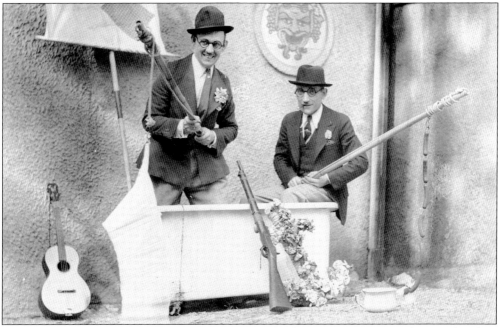

This pair of comedians performed as part of a vaudeville program at Norumbega Park. Their props, including a gun, a cane, sausage links, a guitar, and an assortment of hats, suggest that they presented several skits. The J.W. Gorman Amusement Company of Boston booked the shows at Norumbega. Quite an impresario, Gorman and his associates brought entertainment to amusement parks and other venues in America and Canada.

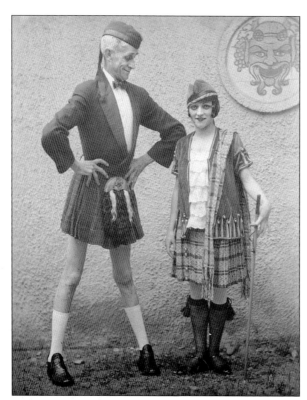

This couple dressed in Scottish clothes to perform their routine. Actors and actresses usually played a variety of roles. "Most of vaudeville calls for more or less of impersonating or character work," noted Frederic LaDelle in *How to Enter Vaudeville*, a self-published guide (1913). "It will be easier for you to do this after you have selected proper wardrobe and makeup to suit the character you represent."

Using no props, Jack Hughes performed in a vaudeville duo at Norumbega Park. A 1921 review in *Dramatic Mirror and Theatre World* (Vol. 83) tendered praise, saying the brother and sister pair "offered some relief from the onslaughts of dance and other things in the way of 'lung' instruments. They pleased extraordinarily."

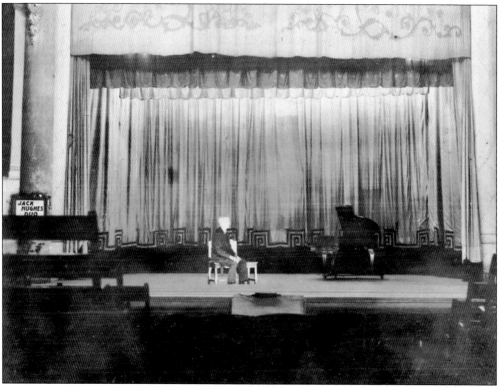

In 1928, Giuseppe Creatore, also known as the "Great Creatore," led the world premiere of the "Colonel Charles Lindbergh March" at Norumbega Park. Lindbergh, the first pilot to fly an airplane solo across the Atlantic Ocean in 1927, inspired more than 300 songs. Born in Naples, Creatore immigrated to the United States in 1899. Though he played the trombone, he was best known for his dramatic flair as a conductor.

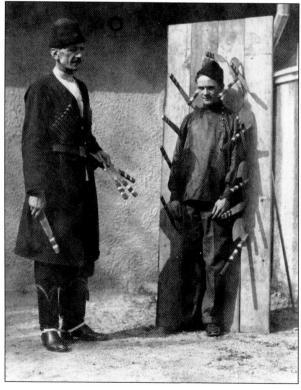

In the late 19th century, knife throwing had become part of a category of circus entertainment called impalement arts. These perilous "arts" involved throwing something dangerous, such as an arrow, a bullwhip, or a knife, toward a human target. The object was not to hit the person but to narrowly miss. Knife-throwing practitioners, such as the performer shown here, had to develop perfect aim with carefully honed blades.

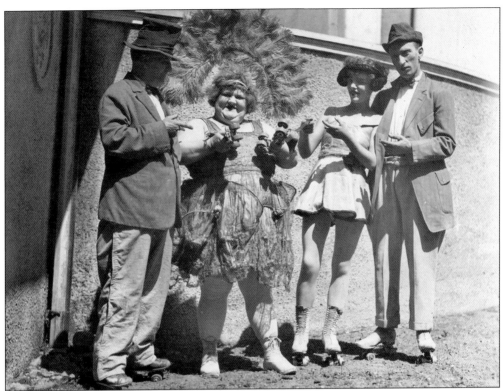

In the early 20th century, people with physical differences, such as the large woman in the headdress, performed in vaudeville shows, making references to their appearance part of the act. In the early 1900s, Sophie Tucker, a national performer, made jokes about her size, singing "I Don't Want to Get Thin." Popular tastes have since changed, and performers now consider it demeaning to call attention to an unusual physical attribute.

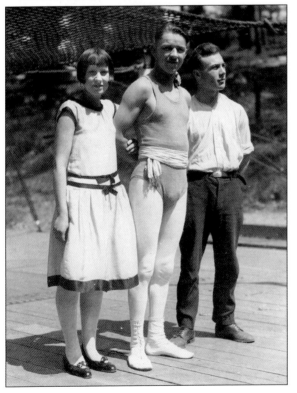

A trio of vaudeville performers takes a break on the outdoor stage behind the Great Steel Theatre. In 1922, the theater presented five vaudeville acts twice each day, with a new bill every week. Each show lasted approximately one and a half hours. During that time, five or six unrelated acts—typically comedians, musicians, acrobats, "talkologists," and novelty acts— each performed one after another.

Some vaudeville shows at the park included dance. On August 7, 1908, the *Newton Graphic* said of a show, "It has a bevy of pretty chorus girls, some clever dancing, beautiful costumes, and funny comedians." One of the female dancers in these photographs dressed as a man, perhaps playing the lead role in a carefully choreographed routine. To give audience members an optimal view of the acts onstage, Norumbega's early-20th-century program books noted, "The LAW reads, 'The licensee SHALL NOT, in his place of amusement, allow any person to wear any head covering which obstructs the view of other spectators.' The management will greatly appreciate if the LADIES will kindly comply with this LAW."

Lines of synchronized leg-kicking became popular in the early 1900s. Nationally, the Ziegfeld Follies and the Radio City Rockettes exemplified this style. Originally called the Rockets and the Roxyettes, the group that became the Rockettes became an instant sensation when it first appeared at Radio City in New York in 1932.

A variety and talent show called *Norumbega Follies* debuted at the park in 1923. Maude Scott directed these amateur entertainers from Greater Boston. A special permit from the City of Newton allowed children to appear in the show. Many American entertainers spent the early part of their careers as child stars in vaudeville, including Mickey Rooney, Sammy Davis Jr., George M. Cohan, Milton Berle, and Judy Garland.

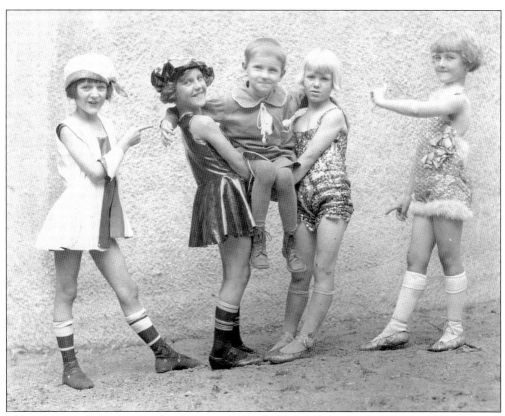

Howard Hawes (center), son of park photographer William Hawes, made the most of his summers at the park by hamming it up with children who appeared in the *Norumbega Follies*. The *Follies* repeated every summer from 1923 to 1929, with a larger cast each season. By 1929, more than 100 performers appeared in the show. Children were an integral part of the troupe.

Using a camera provided by his father, Howard Hawes mimicks paparazzi while his female peers pose like young starlets they had likely seen in Hollywood films. To increase interest in the *Follies*, audience members voted for their favorite performers. Each week, a cash prize was given to those who received the most votes.

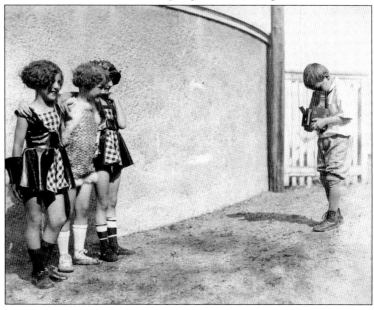

In 1917, Norumbega Park hired its own stock company of actors, the Liberty Players. The troupe presented a new melodrama or musical comedy each week of the summer. The most popular show of the 1917 season was George M. Cohan's *George Washington Jr.*, which featured the song "You're a Grand Old Flag."

Actress Joan Quest played the leading lady in many theater productions. Her real name was Marian Johnquist. Offstage, she was married to Will White, an actor who later became manager of Norumbega Park in the 1920s. Quest died when she was still in her 20s. Later, White married Dorothy Gallant, a classically trained soprano who also performed at Norumbega.

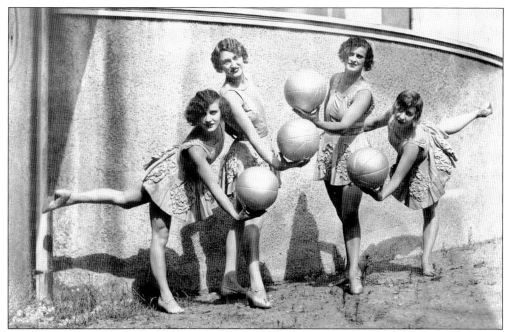

Women who performed together were often called "girl acts." Juggling, associated with circuses since the 18th century, became a vaudeville staple in the 19th century. Sometimes jugglers performed simple tricks between musical acts, but this troupe likely had a show on par with other entertainers. Early jugglers performed with beanbags or balls made of leather or wood. Rubber balls made it possible for jugglers to expand their repertoire. These young women likely practiced for hours to synchronize their movements as they tossed, caught, and traded the balls. Their costumes gave them freedom to bounce the balls under their legs and to reach up and catch balls lobbed over their heads.

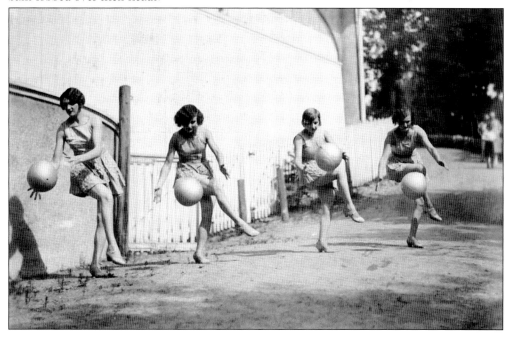

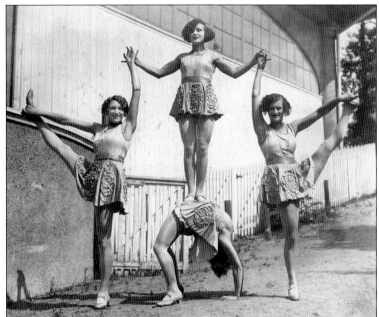

Most vaudeville performers had to be versatile in order to survive. The female jugglers with rubber balls also did acrobatic tricks as part of their act. The Three Lorellas, "Real Comedy Acrobats," who appeared at Norumbega Park in 1910, combined comedy with gymnastic feats. The Golden Gate Trio from 1911 billed itself as "Creole comedians, vocalists, and dancers."

Starting in the early 1900s, many different acrobatic acts performed at Norumbega Park. In vaudeville shows, acrobats usually appeared to add variety between comedy and musical acts. Later, acrobats and aerialists performed in the space outside the theater named the Hollow. These men likely worked together to perform well-executed tricks that wowed the audience.

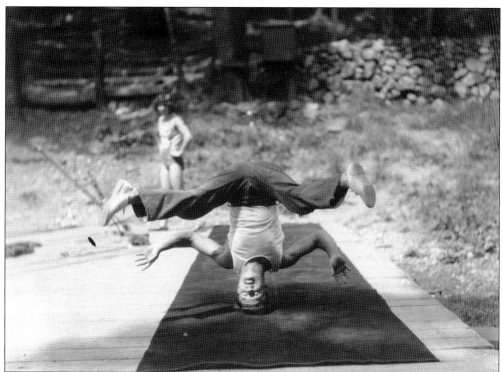

The head stand, now best known as a yoga pose, was frequently part of an acrobatic routine in the early 20th century. Since the stage was used for so many other acts, the acrobats simply unrolled a rug instead of using a more permanent mat. The crowd also enjoyed seeing performers in other dexterous, gravity-defying stunts, including front and back flips, handstands, and tumbling tricks.

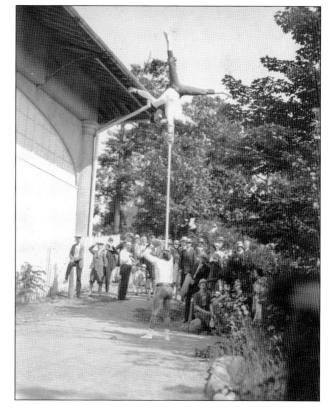

Behind the Great Steel Theatre, acrobats used poles for balancing, lifting each other high into the air as the audience watched with bated breath. These types of performances supplemented the precisely scheduled activities onstage. Spectators could casually drop by to see the acrobats instead of reserving and paying for a seat in the theater.

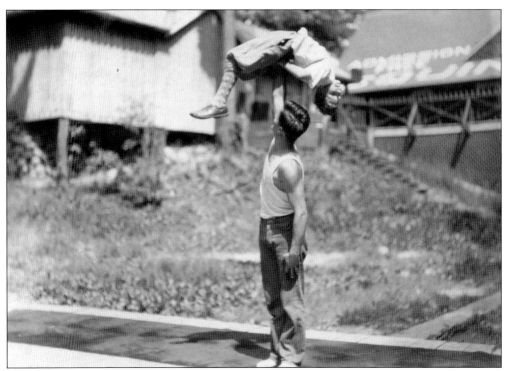

Acrobats in vaudeville often worked in pairs. Given the amount of physical proximity and travel required, male-female duos were often married. In 1914, Brazil & Brazil, "lady and gent equilibrists" (experts at balancing tricks) made an appearance at Norumbega Park. Children performed as acrobats in acts called "kid numbers." Many families also worked and traveled together. The Five Sensational Boises, "Aerial Artists of Extraordinary Skill," appeared at Norumbega Park in 1910. In 1911, the program featured the Claremont Brothers, "Sensational Aerialists on a Revolving Ladder." One of the most famous families of acrobats and aerialists, the Wallendas, began performing with Ringling Bros. and Barnum & Bailey Circus in the 1920s.

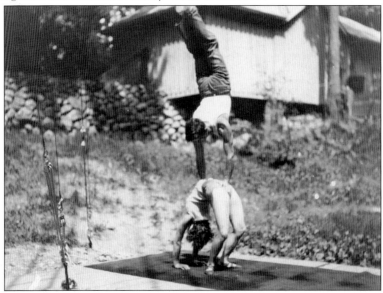

The Aeroplane Girls appeared at Norumbega several times in the 1920s. Capitalizing on the popularity of aircraft in the early part of the 20th century, this pair performed trapeze stunts while revolving on an apparatus that looked like an airplane. Pilot Amelia Earhart became an international celebrity in 1928 when she participated in a nonstop flight across the Atlantic Ocean. She soloed a plane across the Atlantic in 1932.

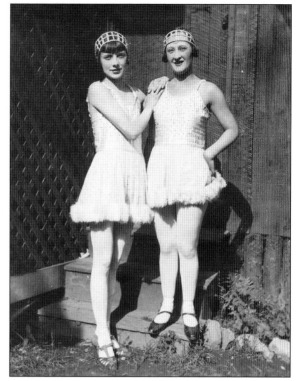

Female aerialists like the Aeroplane Girls pushed the boundaries of physical capabilities as well as traditional gender roles. Other female performers did solo acts. Mazie Lunette stayed at Norumbega Park all season in 1924 to perform her daring "Slide for Life" on an 800-foot cable while hanging by her teeth.

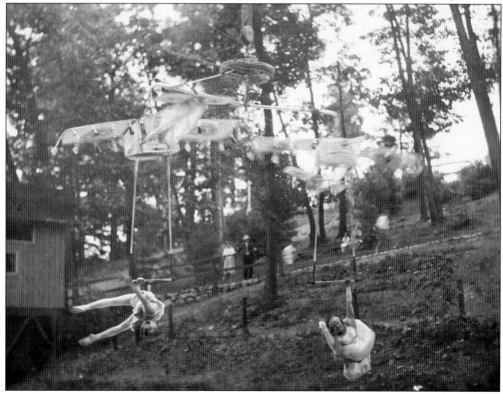

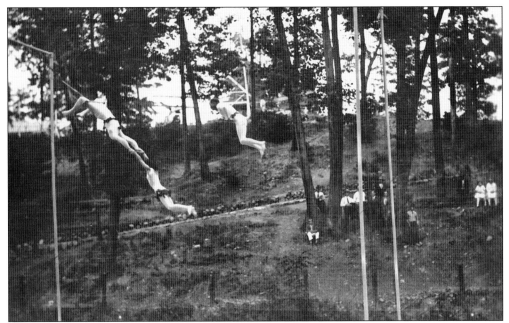

The open-air setting of the Hollow provided plenty of room to set up trapeze apparatus. The one-piece costume that performers often wore is named after a Frenchman, Jules Leotard, who performed the first flying trapeze act at a circus in Paris in 1859. Composer Gaston Lyle and lyricist George Leybourne based their 1867 song "The Daring Young Man on the Flying Trapeze" on Leotard's stunts.

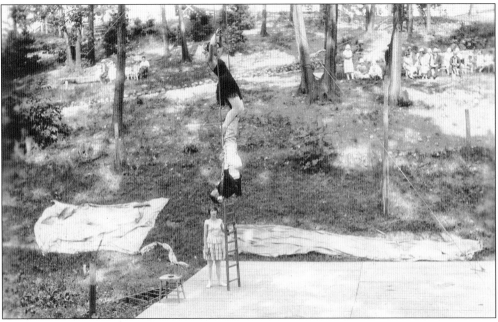

Trapeze acts thrilled crowds but could be dangerous. The Ateno Family acrobatic troupe opened the season at the Hollow in 1926. On July 4, to the horror of more than 1,000 spectators, Gus Ateno fell more than 50 feet to the ground when his trapeze broke. He was rushed to the hospital and suffered only minor injuries. He rejoined the act within a few weeks.

High divers appeared several times at Norumbega Park. In 1924, a diver named "Speedy" plunged 110 feet through a "blaze of fire" into four and a half feet of water. May Collier dove 83 feet in 1929. Sometimes animals got into the act. In 1908, a pair of diving horses acquired from a trainer in Pittsfield, Massachusetts, plunged into the water.

Though their natural habitat is the water, seals can be trained to do circus acts. It typically takes two to six months to teach a seal to balance a ball on its nose. In this act at Norumbega Park, the seals perched on stools and also climbed a ladder. Water from the hose helped keep them cool in hot weather.

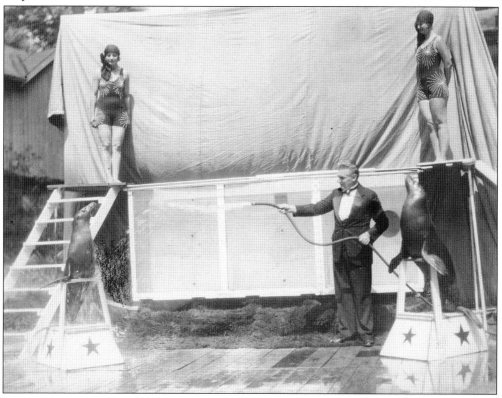

Robinson's Military Elephants stayed at Norumbega Park most of the summer in 1928. The act was billed as "twenty tons of ponderous precocity featuring Tillie, the 110-year-old dancing flapper." Park employee James Washington, who helped take care of the animals during their residency, takes a break to strike a pose on one of the stands used in their act.

In the 1930s, Bill "Swede" Blomberg did trick riding and roping at Norumbega Park. Blomberg had previously worked in a Wild West show. This type of entertainment became popular after "Buffalo Bill" Cody founded his own show, *Buffalo Bill's Wild West*, in 1883. *Cody's Wild West Congress of Rough Riders* at one time featured over 600 performers. His show toured nationally for 30 years and spawned many imitators.

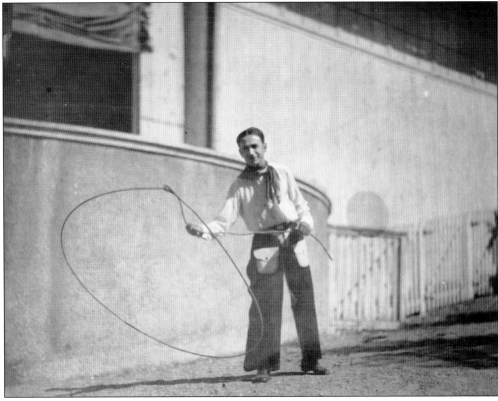

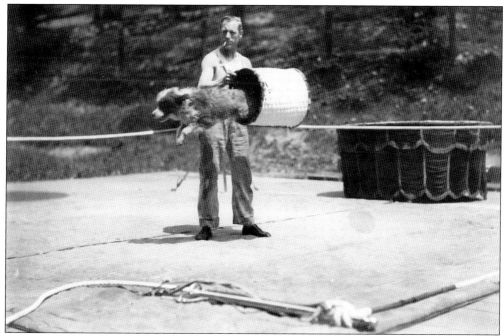

Along with doing trick riding and roping, Bill "Swede" Blomberg ran a circus that featured dogs, monkeys, horses, and a lion cub. Among the dogs were a trained team of Alaskan huskies, including the lead dog, Totem. Pet dogs had a special day at the park in 1923, when the Ladies' Kennel Association of Massachusetts held its first annual dog show. More than 800 canines entered the show. Proceeds benefited the Peabody Home for Crippled Children in Newton. Founded in 1895 in Weston and later relocated to Oak Hill in Newton, the group home cared for children who had suffered from polio or other conditions that limited their mobility. Fundraisers for community charities were frequently held at Norumbega Park.

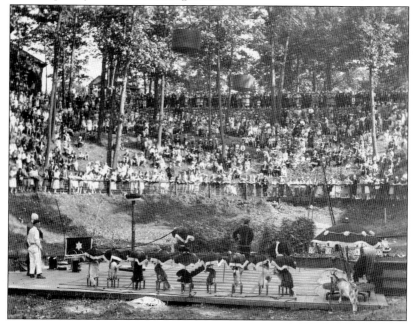

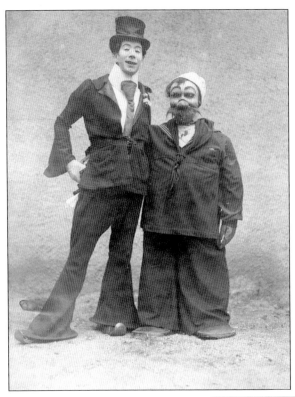

Clowns provided comedy, an essential element in vaudeville shows. Charlie Chaplin, Buster Keaton, and Laurel & Hardy all performed as vaudeville clowns before becoming early-20th-century film stars. Norumbega Park frequently advertised the comedy element of its vaudeville lineup. A 1914 program described Lewis & Young as "comedy entertainers for a good laugh" and the Riverside Four "in a lively round of frivolity." Bawdiness was discouraged among entertainers as well as patrons. "No disorderly person, whether under the influence of liquor or not, will be allowed to enter or remain in the park or theatre. All offenders will be promptly removed," a 1914 program warned.

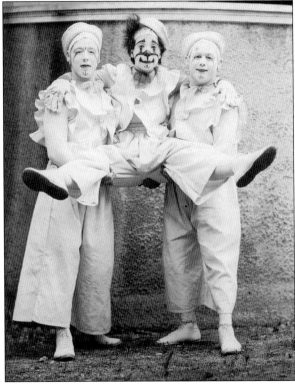

Outside of stage shows, clowns strolled around Norumbega Park to entertain visitors. When Norumbega Park was closed for the winter, Moxo the Clown, left, whose real name was Mark Barker, made charity appearances throughout Greater Boston. The other clown was one of many little people (also called dwarves) who found employment in amusement parks or circuses.

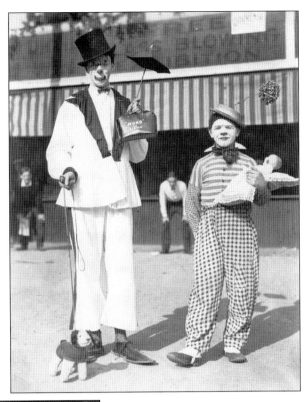

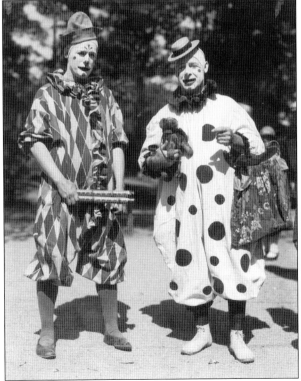

The strolling clowns at Norumbega dressed in colorful costumes, such as these one-piece suits. The clown on the left is holding Chinese sticks with tassels on each end, which are used in magic tricks. The clown on the right uses a stuffed animal and a purse containing other props as part of his routine. A "clown alley" refers to a backstage area where clowns prepare for their performances.

In 1914, there were 14 theater attendants at Norumbega, 11 of whom were ushers. They were expected to model as well as maintain decorum at the park. "Persons will please report to the manager any instance of inattention or incivility on the part of any attaché of the park," a 1914 theater program told visitors. About 50 people worked at the park in all, including 3 ticket takers and 11 laborers and caretakers. Many people fondly remembered these jobs. Ray Hamilton of West Newton worked at Norumbega from 1915 to 1919. He wrote, "My parents operated a small restaurant at our home on Charles Street in Auburndale. My mother was a wonderful cook, and the vaudeville performers from the park used to come to supper between shows. I got to know a lot of them . . . and I canoed on the Charles River with some of the most beautiful girls in the world."

Madame Palfreyman, a fortune teller, held crystal-gazing seances and palm readings in her cottage in 1919. She and her husband lived at the park all summer. Though divination (the art of telling the future) ran counter to most religious teachings, people considered it a form of entertainment in the early 20th century and paid 50¢ for a palm reading and $1 for a crystal reading.

In 1915, Norumbega Park added a photo studio as an attraction. The resident photographer, William Hawes, lived with his family on Commonwealth Avenue across the street from the park. He maintained a record of many of the park's performers and other attractions from 1915 until 1930. His son Howard appears in many of his photographs and also took a few himself.

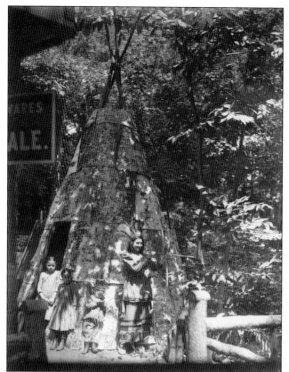

A brochure advertising Norumbega Park in 1930 noted an "Indian Teepee" and "Indian Archery" among the 30 attractions listed. The appropriation of a Native American dwelling and costumes to attract visitors and boost park admission was typical at this time in American history but played up stereotypes about native people as primitive.

The park's Music Court hosted live music. The bandstand could accommodate 35 musicians, and there was seating on wooden benches for up to 400 audience members. People could also sit in the grass. Unlike the vaudeville shows in the main theater, these shows did not require a special ticket. Visitors could stop and listen for a time, then proceed to other attractions.

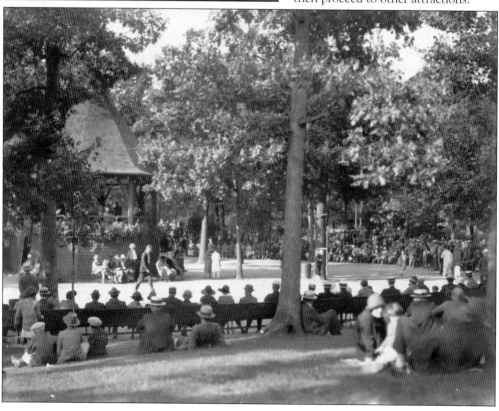

In the 1920s, Dick Crosby led one of Norumbega Park's first house bands. The band accompanied vaudeville acts at the Great Steel Theatre, performed open-air concerts at the Music Court, and also played dinner music at the restaurant. In Norumbega Park's earliest days, concerts were held daily at the Music Court at 1:45, 4:45, and 6:45. These concerts featured local bands, including the Waltham Watch Company Band, the Talma Ladies Military Band, and Knowlton and Allen's Band. Military music was popular for many years, perhaps reflecting the tastes of veterans. In 1904, during a Grand Army of the Republic reunion at Norumbega Park, a quartet sang patriotic songs including "Marching through Georgia." In 1920, Teel's Military Band performed twice daily at the Music Court throughout the summer.

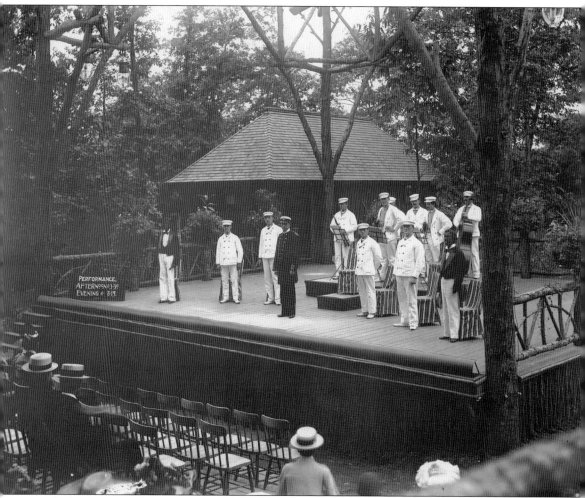

Shameful as it is to look at now, early entertainment at Norumbega Park included white performers appearing in blackface as part of minstrel shows. Frank Newman's Musical Revue, starring famed blackface comic Ted Lewis, performed at the park in 1921. This type of racist show began in New York in the 1830s, when white actors darkened their faces and performed caricatures of enslaved people singing and dancing. Jim Crow, the name of a character invented by Thomas D. Rice, eventually became the nickname for laws restricting Black citizens, especially but not exclusively in the South. Minstrel shows evolved into multipart entertainment that continued through the early 20th century. Though some Black performers, including Bert Williams, created their own minstrel shows as a way to undermine the narrative, the stereotypes of buffoonish Black characters became ingrained in popular culture. Such stereotypes dehumanized Black people and diverted attention from the essential issue of full rights of citizenship for African Americans, including voting.

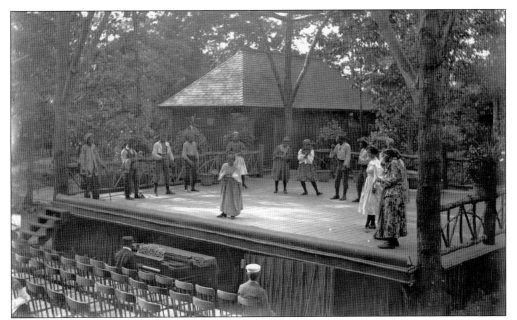

Uncle Tom's Cabin, the novel by Harriet Beecher Stowe that dramatized the moral imperative of abolishing slavery, became a national bestseller after its publication in 1852. Stage adaptations began soon afterwards and proved quite popular with audiences, even though many of these shows took liberties with the text. By the 1890s, as many as 500 different productions of *Uncle Tom's Cabin* toured the country, including one that came to Norumbega.

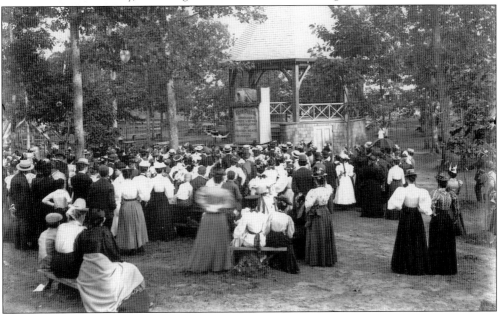

From its earliest days in the 1890s, Norumbega Park's outdoor bandstand supplemented the offerings at the main theater by hosting other types of performances, including this puppet show by Professor Prior, "unequalled, artistic, and refined manipulator of wooden heads." Another "Professor," Doyle Williams, presented a Punch and Judy show, a popular dramatization of a bickering couple that relied on slapstick gags for laughs.

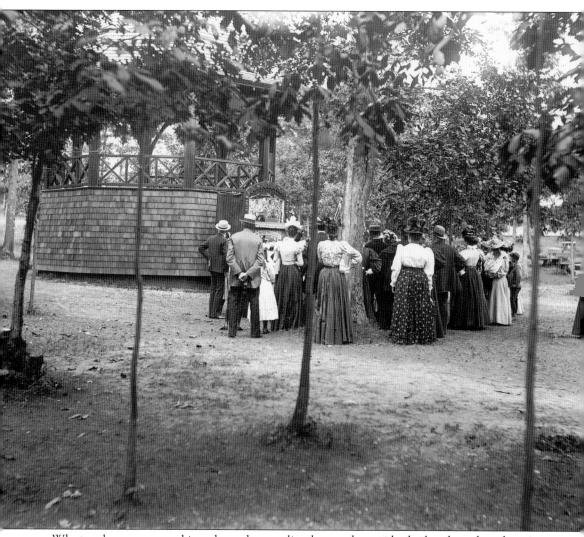

When a show was not taking place, the tree-lined grounds outside the bandstand made a nice spot for a rest. Though the park had official picnic grounds, visitors used the grassy lawn to eat the snacks they had purchased at refreshment stands. Bob Pollock, who grew up in Auburndale and later spent many years documenting Norumbega Park's history, wrote that if he could go back in time, he would gladly relive a day at the park, stretching out on the "lush grass near the bandstand and eating lunch—those delicious grilled hot dogs, washed down with a bottle of Simpson Springs fruit punch, a gourmet meal I can still taste in my dreams. Crickets, red-winged blackbirds, and the sounds of the river would serenade us as we ate and joked under the warm sun."

Five

SNACK TIME

Like most amusement parks, Norumbega Park sold ice cream, soda, and popcorn from several snack bars. Its sit-down restaurant, part of the original design, gave people another reason to visit the park. Named the Pavilion, the restaurant opened on July 4, 1897, just a few weeks after the park began operating. Its first chef, former high-end hotel proprietor Joseph Lee, set the standard that helped the dining room establish itself as a destination known for excellent food in an elegant atmosphere. Before 1940, when the Totem Pole Ballroom added heat and expanded its schedule, the restaurant was the only facility at Norumbega that remained open during the winter months.

The name, decor, and menu at the restaurant changed many times over the years. The spot became the Grape Arbor Café in 1910 and the Chauve Souris in 1923. The Ginter restaurant chain took it over in 1929 and renamed it Ginter's Old Venice, painting the walls with murals of Venetian canals and gondolas. These murals remained even after the room became the Normandie Restaurant. No matter what the name, the restaurant always made the most of its Norumbega Park affiliation. Musicians who performed at other venues in the park also entertained diners. Special menus often included park admission.

The Normandie Restaurant temporarily closed in 1942 and became a US Army training facility for the 32nd Ordnance Medium Maintenance Company. In 1946, the facility reopened as the Normandie Room, a function hall for weddings and other events. It stayed in business until the park closed.

Outside of the restaurant, refreshment booths in the park provided sandwiches as well as snack foods. Norumbega was one of the first amusement parks in the nation to install water fountains. Some parks deliberately omitted them because that way thirsty patrons would be forced to buy soft drinks. The Totem Pole Ballroom, which opened in 1930, also operated a soda fountain. Alcohol was served with restaurant meals (except during Prohibition from 1920 to 1933), but not inside the park, which helped maintain Norumbega's wholesome reputation.

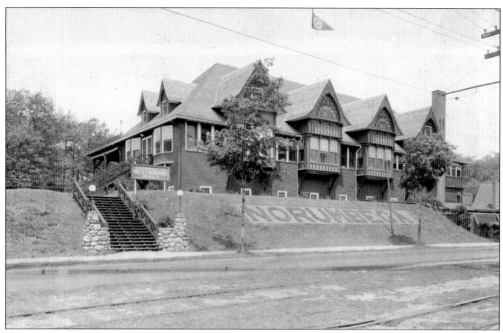

When the original Pavilion restaurant opened in 1897, it could seat 250 diners. Large windows facing southeast took advantage of the cool breezes from the river. The sign on the front doubled as a marquee for Norumbega Park. The letters cut into the grass out front also advertised the entrance to the park.

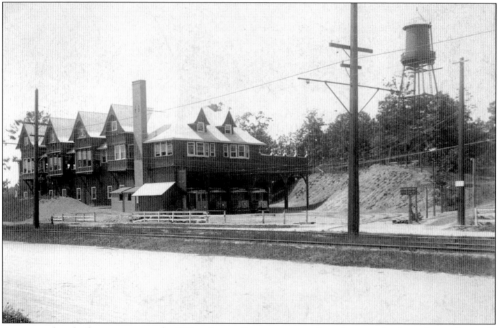

At street level, the restaurant building housed a turnaround and a repair shop for trolleys. A 10,000-gallon tower behind the restaurant stored fresh water for the park. The water fed a sprinkler system in the carbarn and restaurant to prevent fires. In addition, a network of underground pipes provided irrigation for the trees, grass, and flowers. The tower was removed in 1927.

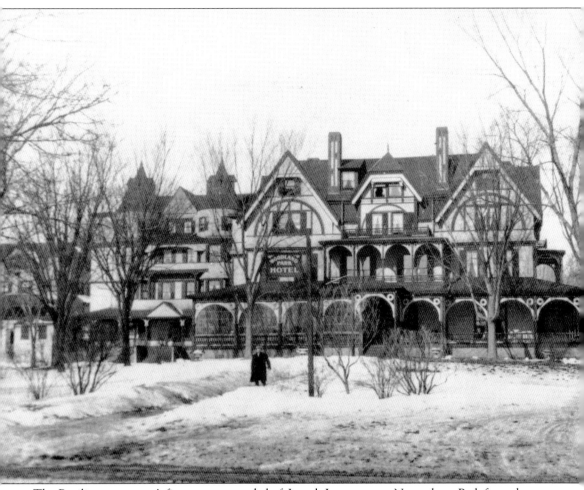

The Pavilion restaurant's first manager and chef, Joseph Lee, came to Norumbega Park from the Woodland Park Hotel in Auburndale. An African American man born into slavery in South Carolina, Lee gained his freedom after the Civil War and made his way to Boston as a cook on various ships. In 1883, he became the owner of the Woodland Park Hotel. In addition to operating a dining room, Lee oversaw a large catering business that included delivery of custom-made fancy cakes. Three US presidents visited the hotel: Chester A. Arthur, Grover Cleveland, and Benjamin Harrison. Lee also invented a machine for kneading bread and another for making bread crumbs, leading him to later be inducted into the National Inventors Hall of Fame. After leaving Norumbega Park, Lee opened a catering business in Boston and a restaurant in Squantum (near Quincy, Massachusetts), continuing until his death in 1908.

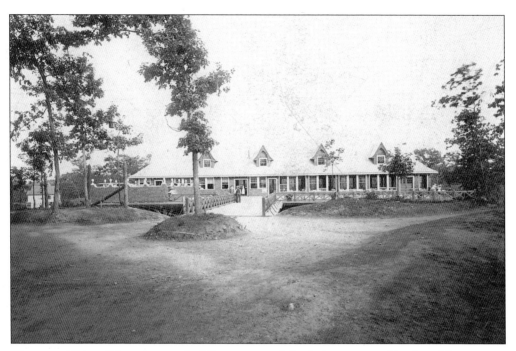

The second floor of the restaurant building contained the dining room and kitchen. The capacity of the Pavilion restaurant increased to 600 with the addition of an outdoor patio and roof garden in 1901. In 1904, diners were entertained by "verandah concerts" presented by the musical groups that also appeared each week on the Norumbega bandstand.

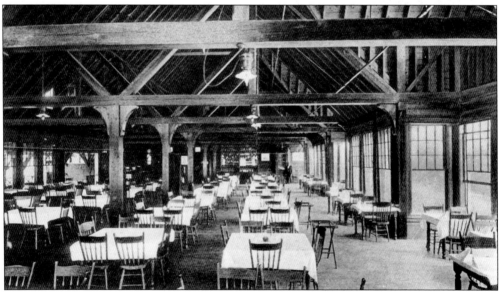

The Pavilion was renamed the Grape Arbor Café in time for the 1910 season. The name came from a successful restaurant on Islington Road in Auburndale that had closed 25 years before. In 1914, orchestra concerts were held at the restaurant twice each evening, before and after the theater performance. The restaurant was renovated in 1918 to add a floor for dancing. The Norumbega Jazz Orchestra was a favorite.

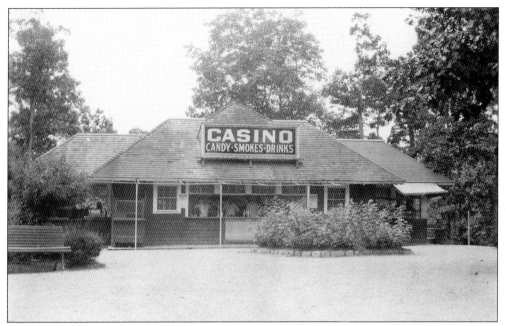

Inside the park, a large stand named the Casino provided sandwiches, popcorn, candy, and soft drinks. There were two other refreshment booths inside the park and a small restaurant on an island next to the Norumbega boathouse. In the mid-1930s, the Casino sign was replaced with a movie screen. The building became known as the Clam Shack around 1947.

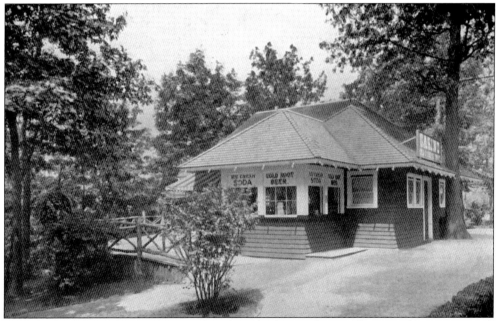

After the Casino changed its name to the Clam Shack, Orville B. "Ollie" Haughn came to work at Norumbega and managed the food concessions for many years. Haughn sold fried clams, french fries, pizza, soda, cotton candy, and coffee, along with firewood for the park's outdoor picnic grills. In the 1950s, he became a state representative in Maine but continued to work at Norumbega each summer when the legislature was not in session.

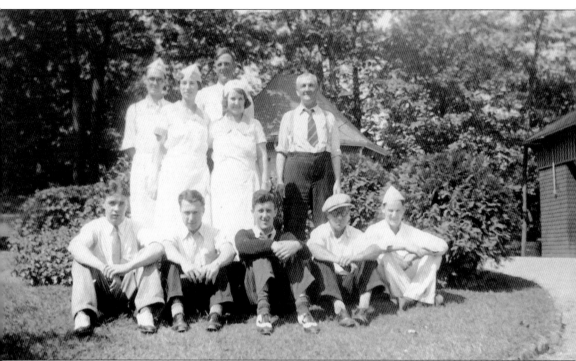

Employees of the Casino and other concessions sometimes had to do more than serve drinks and snacks. Auburndale native Don Lunny worked at Norumbega Park in the 1940s. He remembered that occasionally one of the zookeepers would forget to lock the bear cage and an animal would escape for "a little excursion" through the park. "They were pretty tame, and would go right up to people looking for popcorn or a bit of hot dog. Of course, not everyone knew the bears were tame, and the people who came face to face with them would take off running in the opposite direction," he said. A five-gallon drum of ice cream once came in handy when a bear cub escaped. "The bear began to lick at the ice cream, and Freddie [Fred Balboni, a park manager] led him back to the cage," Lunny recalled.

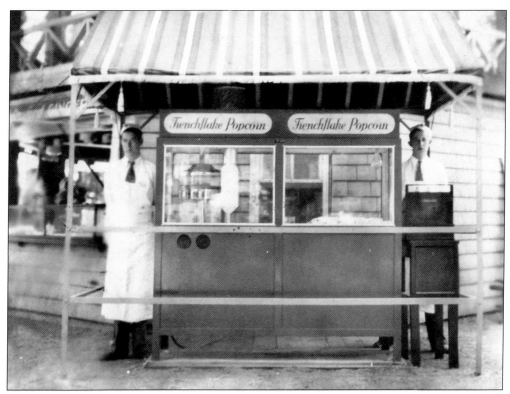

This Frenchflake machine from the Cleveland-based US Popcorn Machine company efficiently produced popcorn all day. In 1947, Norumbega Park installed one of the world's first microwave ovens, a Radarange invented by Newton resident Percy Spencer, a scientist at the Raytheon Company. It weighed 750 pounds and cooked popcorn as well as steaks and hot dogs. Apparently, patrons were more interested in seeing the microwave than in tasting the food, and it was removed after a few seasons.

In the 1920s, the Waldorf corporation managed food and beverage concessions at Norumbega. The company began as Waldorf Lunch in Springfield, Massachusetts, in 1904. Owner Henry Kelsey's concept of standardized restaurants serving good, reliable food was a precursor to national chain restaurants. Waldorf Lunch soon opened additional locations throughout New England and at one time ran 200 restaurants, including 39 in Greater Boston. The company was sold in the 1960s.

In the 1920s, Norumbega sold close to a million bottles of soda a season. Simpson Springs and another company, Pureoxia, provided more than a dozen different flavors, including birch beer, as well as sparkling grape, orange, lemon, or lime crush. In later years, Norumbega simplified its drink selection, selling only Coca-Cola, root beer, noncarbonated orange drink, and soda fountain flavored drinks, all in paper cups.

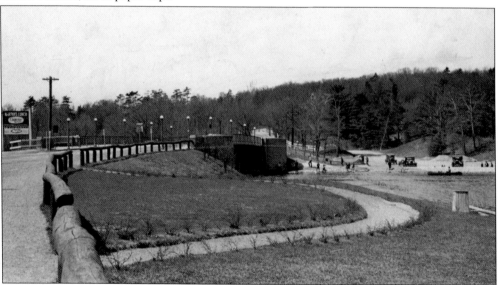

Martha's Lunch opened in 1926 on Commonwealth Avenue outside the gates of Norumbega Park. Despite river views and proximity to the park, the location proved unsuccessful for Martha's and the half-dozen businesses that followed. The Charles Confectionery, McVean's Ice Cream, the Bridge, and Jane's Luncheonette all failed. In the 1950s, a Dairy Queen set up shop, but closed a few years later.

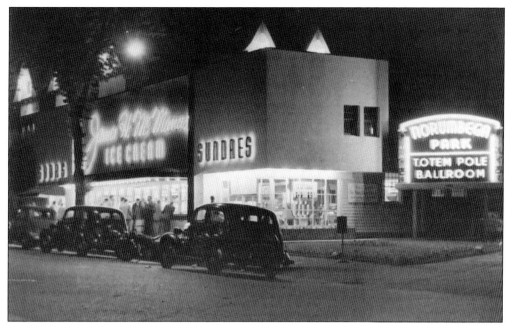

The James H. McManus Company owned and operated the ice cream stand in front of Norumbega Park for more than a decade. The Auburndale stand also provided meals for the inmates at the West Newton jail. Twice each day, a police cruiser would pick up the meals: a hamburger, a brownie, and a soda for each person. The City of Newton was billed each month.

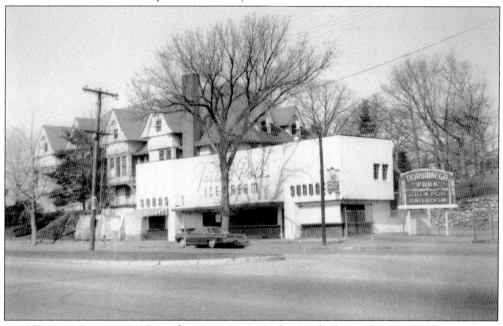

In 1957, Doug Farrington, Norumbega's manager, took over the lease of the ice cream stand and renamed it Totem Pole Ice Cream to capitalize on the popularity of the ballroom. The stand continued to sell McManus ice cream when it was available. Because the stand was located on Commonwealth Avenue, it became a favorite place for local residents who wanted a treat without having to go inside the park.

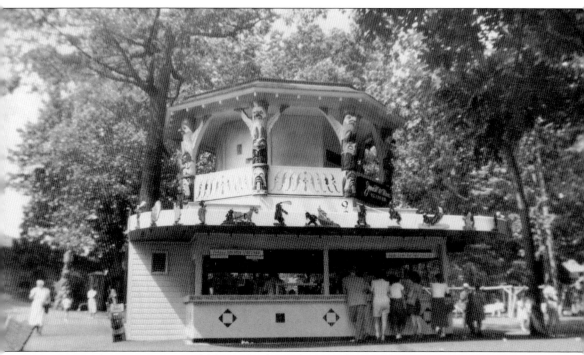

McManus ice cream was available inside the park, too. This stand, decorated with totem poles to echo the theme of the Totem Pole Ballroom, sold ice cream and other snacks. The McManus company started in 1927 and at one time operated 18 stands in Greater Boston, advertising itself as "New England's Most Famous Ice Cream." The brand had many fans. Roger Berkowitz, whose family started the Boston-based Legal Sea Foods restaurant chain and who later became president and chief executive officer of the business, said in an article in the *Boston Herald* on September 24, 2014, that he fondly remembered McManus ice cream. "This store had a flavor called 'Country Club' which had coffee ice cream layered between vanilla ice cream and orange sherbet. The absolute perfect combination of flavors—in my mind, anyway," he said.

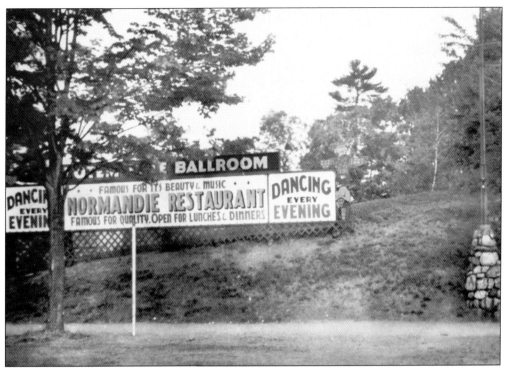

Roy Gill renamed Norumbega's restaurant the Normandie soon after he took over as manager of Norumbega Park in 1938. This restaurant only lasted until 1942, because wartime food rationing and gasoline shortages cut significantly into its business. Gill then rented the building to the US Army's 32nd Ordnance Medium Maintenance Company, which used the street level as a barracks and the dining level as the mess hall.

The Normandie Restaurant's menu catered to park patrons as well as the local community. The $1 dinner menu gave diners an easy way to gain admission to the Totem Pole Ballroom and other nighttime attractions at the park. The "Business Men's Luncheon" attracted those who worked in Newton and other nearby locales but also appealed to people who wanted to make a lunchtime excursion to a scenic spot.

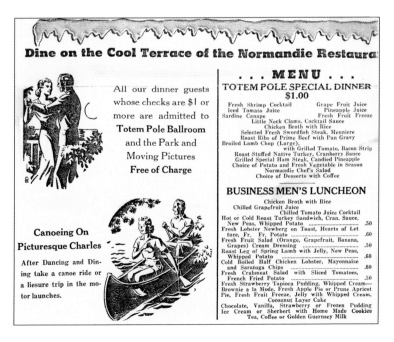

Dine on the Cool Terrace of the Normandie Restaura

All our dinner guests whose checks are $1 or more are admitted to **Totem Pole Ballroom** and the Park and Moving Pictures **Free of Charge**

Canoeing On Picturesque Charles

After Dancing and Dining take a canoe ride or a liesure trip in the motor launches.

. . . MENU . . .
TOTEM POLE SPECIAL DINNER
$1.00

Fresh Shrimp Cocktail Grape Fruit Juice
Iced Tomato Juice Pineapple Juice
Sardine Canape Fresh Fruit Freeze
 Little Neck Clams, Cocktail Sauce
 Chicken Broth with Rice
 Selected Fresh Swordfish Steak, Meuniere
 Roast Ribs of Prime Beef with Pan Gravy
Broiled Lamb Chop (Large),
 with Grilled Tomato, Bacon Strip
 Roast Stuffed Native Turkey, Cranberry Sauce
 Grilled Special Ham Steak, Candied Pineapple
 Choice of Potato and Fresh Vegetable in Season
 Normandie Chef's Salad
 Choice of Desserts with Coffee

BUSINESS MEN'S LUNCHEON
 Chicken Broth with Rice
 Chilled Grapefruit Juice
 Chilled Tomato Juice Cocktail
Hot or Cold Roast Turkey Sandwich, Cran. Sauce,
 New Peas, Whipped Potato50
Fresh Lobster Newberg on Toast, Hearts of Let
 tuce, Fr. Fr. Potato .. .60
Fresh Fruit Salad (Orange, Grapefruit, Banana,
 Grapes) Cream Dressing50
Roast Leg of Spring Lamb with Jelly, New Peas,
 Whipped Potato .. .60
Cold Boiled Half Chicken Lobster, Mayonnaise
 and Saratoga Chips .. .60
Fresh Crabmeat Salad with Sliced Tomatoes,
 French Fried Potato .. .50
Fresh Strawberry Tapioca Pudding, Whipped Cream—
Brownie a la Mode, Fresh Apple Pie or Prune Apricot
Pie, Fresh Fruit Freeze, Jelly with Whipped Cream,
 Cocoanut Layer Cake
Chocolate, Vanilla, Strawberry or Frozen Pudding
Ice Cream or Sherbert with Home Made **Cookies**
 Tea, Coffee or Golden Guernsey Milk

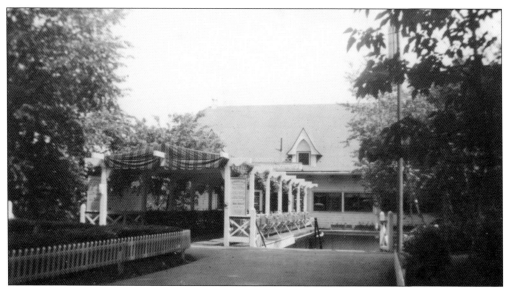

The Normandie Room became a place for private as well as community functions. Norumbega Park manager Roy Gill allowed military veterans to hold wedding receptions there for no cost. Starting in 1944, the Normandie Room hosted an annual Halloween party for local junior high school students. Newton High School students went to the Totem Pole Ballroom on Halloween.

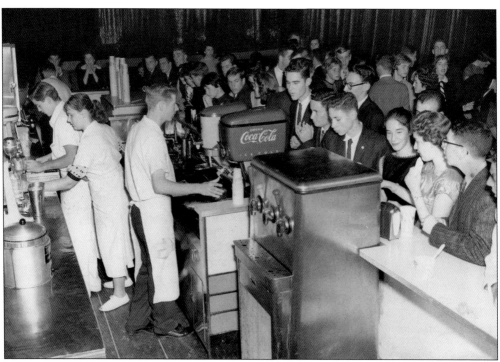

The Totem Pole Ballroom operated its own refreshment stand to sell soft drinks. Here, thirsty patrons line up on New Year's Eve in 1959. Many parents willingly sent their teenagers to the Totem Pole on this holiday because they knew that alcohol was not allowed. People remembered the atmosphere in the ballroom as very formal and proper.

Six

"AMERICA'S MOST BEAUTIFUL BALLROOM"

Norumbega Park's transformation of its 3,500-seat Great Steel Theatre into the Totem Pole Ballroom dance hall began in 1930. Though the theater had successfully presented both live vaudeville shows and motion pictures for more than 30 years, the entertainment industry was changing. Movies had become more popular, and profitable, than live acts. Yet as a seasonal facility, Norumbega Park could not compete with year-round movie houses for first-run films. The park's directors proposed turning the theater into a dance hall to attract new business.

The Newton Board of Aldermen in April 1930 debated whether to approve the new ballroom. Though some officials objected, Alderman John Gordon of Auburndale pointed out that he would "rather have the young people dancing at Norumbega Park than parked in automobiles on dark roads in Weston." His view prevailed, and the permit was granted. Renovations to the Great Steel Theatre began immediately, and the Totem Pole Ballroom opened on May 24, 1930.

The Totem Pole was one of more than 100 dance halls in Greater Boston, including two others along the Charles River: Nuttings in Waltham and Moseley's in Dedham. It distinguished itself for booking nationally renowned big bands in an elegant, romantic setting. As the popularity of the Totem Pole grew, the park began advertising the ballroom as a destination, with the amusement park as an added attraction. A formal dress code, a requirement for couples only, and no alcohol kept the atmosphere classy instead of rowdy. Live radio broadcasts from the ballroom over national networks enhanced the Totem Pole's reputation. So did a write-up in *Billboard* magazine calling the Totem Pole "America's most beautiful ballroom."

The Totem Pole remained a popular destination until the middle of the 1950s, when audiences became more interested in other kinds of music and entertainment. The ballroom closed in 1964 and sat vacant for nearly three years as developers made plans for the property. The building was eventually destroyed by fire, but many patrons still fondly remember the romance of dancing in the ballroom and strolling through the park that surrounded it.

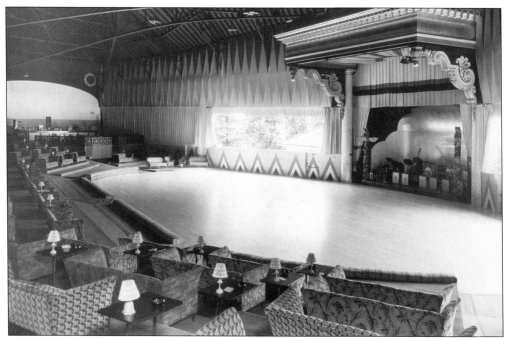

The structure of the Totem Pole Ballroom remained essentially the same as the Great Steel Theatre, built in 1910. It had a pitched roof supported by steel beams and walls open to the sides and rear. The architectural firm of Reinhard and Hofmeister designed the ballroom. The firm's next big commission was Radio City Music Hall in New York City.

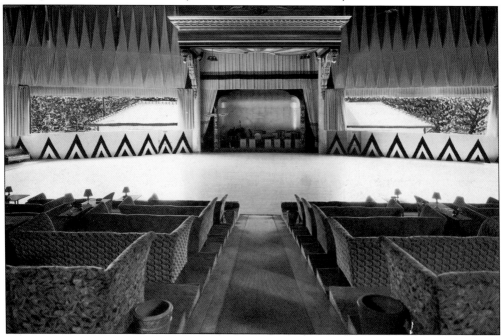

When the Great Steel Theatre was retrofitted to create the Totem Pole Ballroom, the theater's wooden seats were removed and replaced with 150 sofas arranged in tiers. The proscenium arch remained, but the stage became a bandstand. A large maple dance floor filled the space in front of the stage.

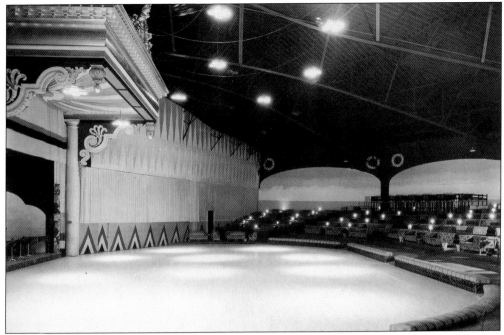

Arch Clair, manager of the park from 1930 to 1937, selected the two totem poles, one of which is shown next to the stage, that gave the ballroom its name. Purchased in Seattle, Washington, the poles were said to be ceremonial carvings by the Kwakiutl people of the Pacific Northwest. This type of cultural appropriation of native artwork is now recognized as disrespectful and inappropriate.

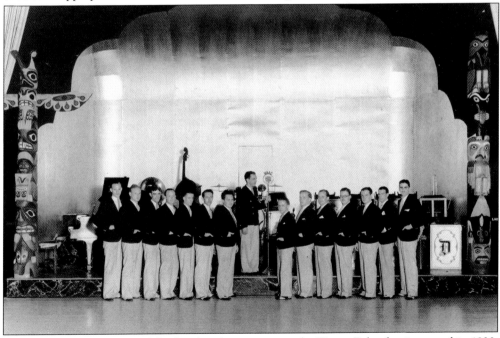

Emery Daughtery led one of the first bands to appear at the Totem Pole after it opened in 1930. "Dance to Daughtery" became a popular slogan. At first his band was called the Playboys, but in 1931, he changed the name to the Tom-Tom Boys, a reference to the native American theme.

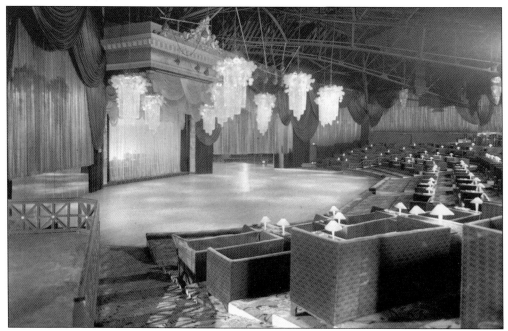

During its first season, the Totem Pole was open for dancing Monday through Saturday evenings. To accommodate the late-night crowd, the park's Ginter's Old Venice restaurant remained open so people could order a meal after the Totem Pole closed at 1:00 a.m. Since dancing was prohibited on Sundays, the ballroom held afternoon and evening concerts.

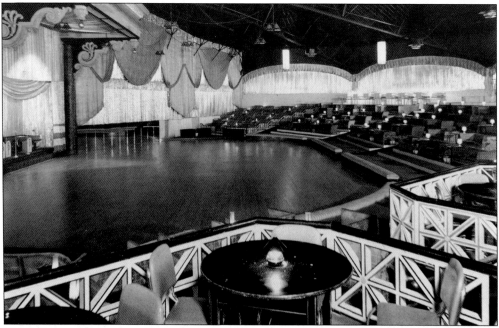

The ballroom was renovated before its second season, adding another dance floor and what an ad called "modernistic electrical effects." The colored lights created "exquisite grandeur," the *Boston Post* wrote on April 26, 1931. "As a whole, Totem Pole Ballroom may now be well said to be in a class by itself. We haven't seen anything just like it in these parts, and it is sure to create a sensation."

Phil Baxter was one of the first musicians to perform at the Totem Pole. Early advertisements for the ballroom ran in the local newspaper, the *Newton Graphic*, but park management stopped advertising there in 1932. Instead, they attempted to expand the audience by focusing publicity campaigns primarily in Boston media.

In the early 1930s, the Totem Pole began radio broadcasts of half-hour programs of live music every night except Sundays. In the 1950s, Boston station WEEI broadcast the music of Freddy Guerra's Orchestra each Friday at 9:05 p.m. Here (from left to right), WEEI's John Marion appears with vocalists Joe McPherson and Bobbi Baxter, bandleader Guerra, and singer Jerry Vale. These programs helped promote the ballroom.

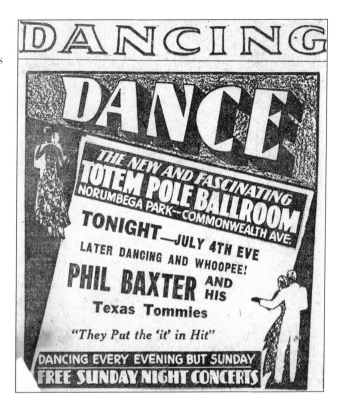

Though the Totem Pole Ballroom was an instant success, it could not offset the losses that Norumbega Park sustained during the Great Depression. In 1938, when the park's owner, the Middlesex & Boston Railway, threatened to close, Roy Gill stepped up as manager and future owner under a lease-buy arrangement. He successfully and profitably ran the ballroom and park until he sold it in 1956.

Reflecting a change in the needs of park patrons, the Women's Cottage closed in 1941 and was transformed into the Teepee Room. Connected to the main ballroom by a covered walkway, it had its own refreshment stand, which helped alleviate crowding in the main ballroom. Hassocks that surrounded a stone fireplace offered a limited amount of seating.

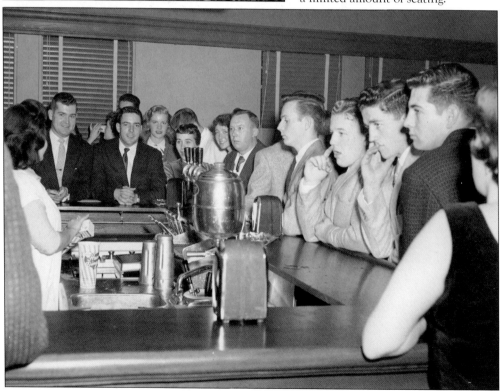

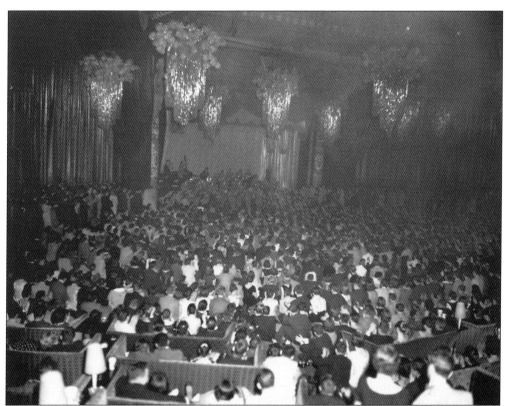

Popular bands often attracted up to 2,000 people, the limit set by Newton fire regulations. Despite security guards, fans sometimes mobbed the performers. Betty Lee Sheffield, who grew up in Auburndale, remembered that one night souvenir-hunters tore Tony Bennett's outfit, leaving him in his underwear. She and her brother ran home and supplied Bennett with enough clothing for him to finish the night.

Though this Norumbega Park constable looks stern, sometimes the security staff humored children. Geoffrey J. Aucoin remembered peeking into the Totem Pole at the end of an excursion to the park. One boy kicked the policeman at the door in the shins and asked, "Hey, mister, can you lift me up?" The policeman said, "Yes, son." Before long, the man had lifted many children, including Aucoin and his friends.

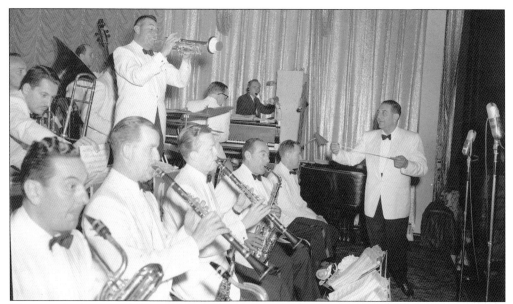

The months between May 1940 and October 1941 brought Guy Lombardo, pictured, and a roster of equally famous big band leaders to the Totem Pole, including Benny Goodman, Woody Herman, Red Norvo, Charlie Spivak, and Harry James. When Bob Crosby appeared in 1939, his brother, Bing, came to Norumbega Park and was thrown out for sipping from a flask. There were no exceptions to the park's alcohol prohibition.

The Totem Pole hosted many beauty contests over the years, including one in 1941 to select "Miss Apple Blossom Queen of Massachusetts." Guy Lombardo's performance in 1960 coincided with another pageant. These six contestants enjoyed stepping onstage with the famous Lombardo, a celebrity by then best known for his annual New Year's Eve concert. He began broadcasting on the radio in 1928 and switched to television in 1956.

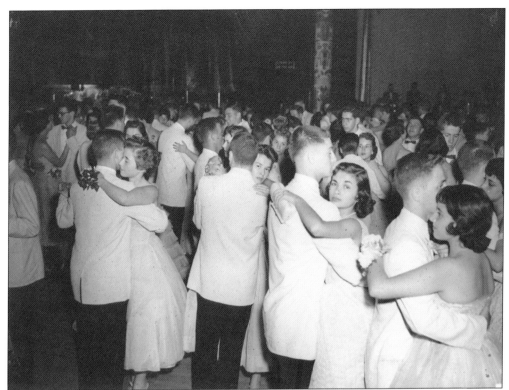

In 1940, the Totem Pole became couples only. A date signaled a special occasion. "Every boy understood that there was no more enticing an offer he could make, and every girl appreciated the zeal of pursuit represented by the invitation," wrote Paul Benzaquin in the *Boston Herald* on November 18, 1964. Singles without a date occasionally asked a sibling, or even a parent, to accompany them.

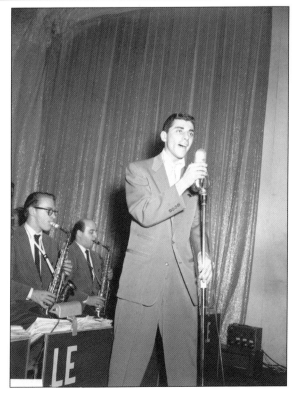

Norumbega Park management in the 1930s began discussing options for enclosing and heating the ballroom, but the large space proved daunting. In October 1940, a heating system was finally installed. It did not work well, and performers remember wearing long underwear, wool socks, and gloves during the winter months. This singer's fashionable jacket also kept him warm.

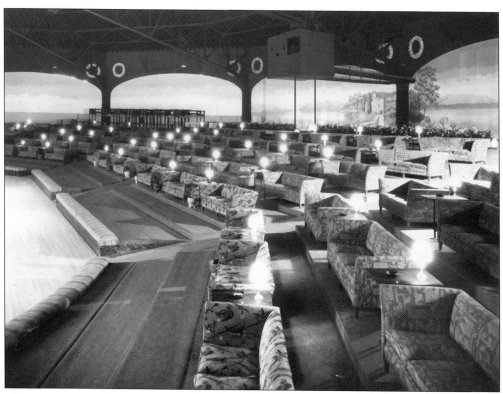

In the 1940s, a two-person sofa could be reserved for 50¢, a large one for $1. Many couples fondly remember snuggling on these couches. New glass drapes and chandeliers were installed in 1941, along with custom carpeting with the Totem Pole logo, musical notes, and a piano keyboard. The carpet salesman, Don Kent, became a well-known weather reporter on Boston station WBZ.

DICK JURGENS'

FAREWELL (for a while) to

TOTEM POLE

Dick Jurgens, a West Coast bandleader, arrived for a show on Memorial Day in 1942 and stayed for nine weeks. Huge crowds turned out to listen and dance to his band. His upbeat music helped ease wartime fears. The Totem Pole remained open after the United States entered World War II in 1941, but by the winter of 1942–1943, it limited its schedule to Saturday nights because of fuel restrictions.

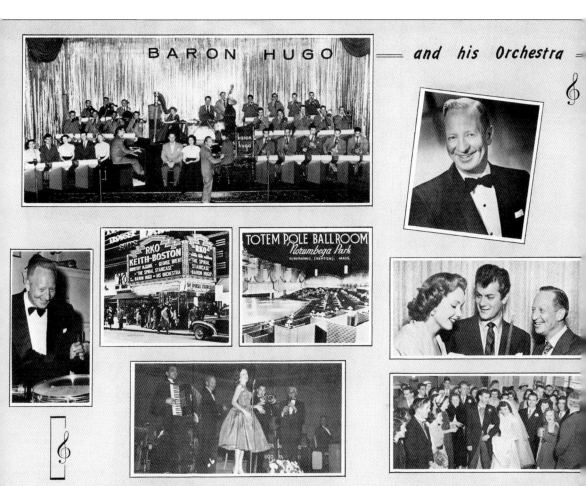

Known as "Baron Hugo," Hugo E. Lira first performed at the Totem Pole in 1943 and continued as the house bandleader until 1951, earning the nickname "King of the Totem Pole Ballroom." A self-taught musician, Lira performed around the Boston area before coming to the Totem Pole. His wife, Edith Hamilton, was from Auburndale and encouraged him to audition there. The Baron Hugo Band became a fixture, starting with 12 musicians and ending with 35. Outside of the Totem Pole, the Baron Hugo Band performed "The Star-Spangled Banner" at a 1948 World Series game between the Boston Braves and the Cleveland Indians. Wearing tricornered hats, they also debuted the Patriots fight song at the opening game of the American Football League in 1960. Lira died in 1992 at the age of 88.

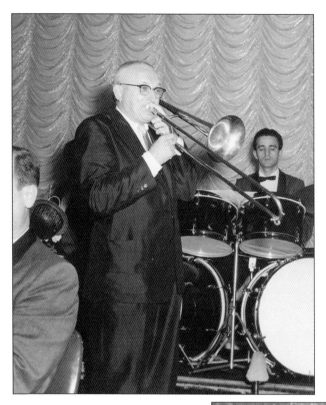

Tommy Dorsey first performed at the Totem Pole in 1940 and continued to occasionally headline into the 1950s. Frank Sinatra appeared with Dorsey and his band in 1940–1941 before leaving to become a solo act. Dorsey started as a trombone and trumpet player and also performed with his brother, Jimmy, before becoming the leader of his own band.

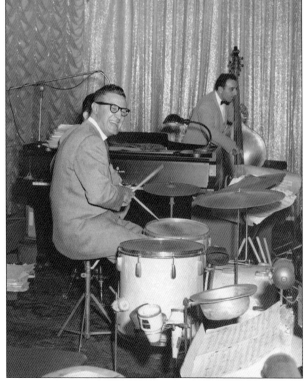

It is not clear whether bandleader Glenn Miller performed at the Totem Pole before his airplane went missing in 1944. After the war, the Glenn Miller Orchestra, led by Ray McKinley, visited the ballroom. McKinley had played with Miller in the Army Air Force band. Miller's songs topped the charts from 1939 to 1943, and successive bandleaders, including McKinley, continued to recreate Miller's distinctive sound.

Glenn Miller's fans continued to buy his records after his untimely death. This couple is following the dress code for the Totem Pole. Ladies had to wear stockings with their dresses, except during World War II, when nylon and silk were in short supply. Men who arrived looking too casual could rent a jacket and tie at the ticket window at the front of Norumbega Park.

In 1952, Newton High School began holding its senior proms at the Totem Pole Ballroom. The yearbook described this event, headlined by the nationally renowned Tommy Tucker and his orchestra, as "a successful and memorable evening." After that, Newton High School held all of its proms there until the ballroom closed. These promgoers take a break from dancing at the park's midway games.

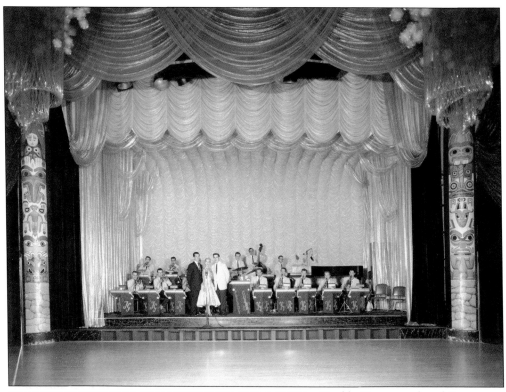

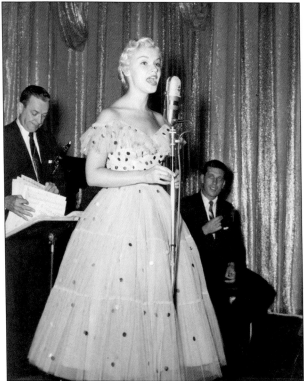

Freddy Guerra replaced Baron Hugo as the house bandleader in September 1951 and stayed for five years. He had played saxophone with Glenn Miller's band before going out on his own. Music journalist Nat Hentoff described the Guerra band as a "crack local unit" in an article in *Downbeat* on April 22, 1953.

One of the regular vocalists with the Freddy Guerra band, Betty-Jo "Bobbie" Baxter, also recorded for RCA on the Vic label and made numerous radio commercials in the Boston area. Bob Jones, who held several jobs at the park, including soda jerk and spotlight operator, fondly remembered the Guerra band. Totem Pole performers from out of town occasionally stayed at his family's home in Auburndale.

In 1957, Bob Bachelder and his band replaced Freddy Guerra. Bachelder would continue as the house band leader until the ballroom closed. A musician as well as an arranger, Bachelder's "TV Rhumba" medley of theme songs became a national hit song in 1953. He also had a doctorate in school administration and worked as the associate superintendent of schools in Melrose, Massachusetts.

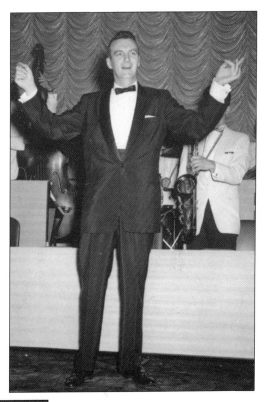

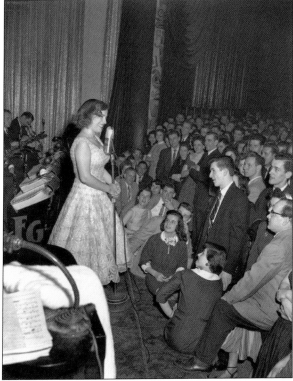

A live television show, *Totem Pole Matinee*, debuted on Boston's Channel 4 in 1954, featuring Joni James. Each week, big-name vocalists like James performed their current hits before a crowd of enthusiastic teens. Radio personality and Newton resident Kenny Mayer produced the show. Though the show was successful, Roy Gill dropped it in 1955 because he thought that rock and roll was unsuitable for the Totem Pole.

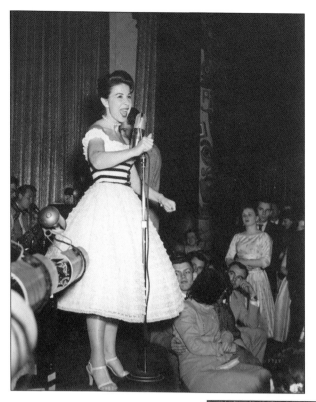

Singer Eydie Gormé toured with bandleaders who performed at the Totem Pole, including Tommy Tucker and Tex Benecke. Later in her career, she became a cast member of *The Tonight Show*. She also frequently performed with her husband, Steve Lawrence. They won a 1960 Grammy Award as the best pop duo.

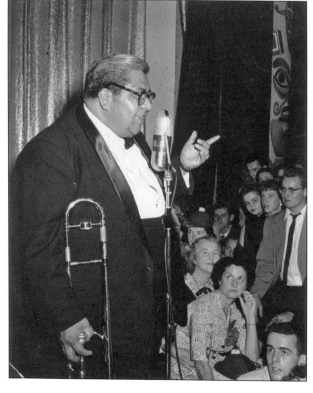

A close associate of the classic jazz greats, Russell "Big Chief" Moore appeared at the Totem Pole as a star trombonist. He had toured with Louis Armstrong and Lionel Hampton. A member of the Native American Pima people, Moore went on to lead his own band in the 1960s and 1970s.

Pop vocalist Don Cherry had many hit singles in the 1950s. A native Texan, he delivered singing telegrams when he was a high school student. Though he sang with a big band at the Totem Pole, he also appeared on radio and television variety shows. He later became the voice of the Mr. Clean cartoon character in commercials. When not onstage, he was a professional golfer.

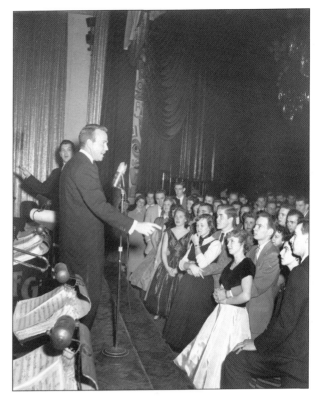

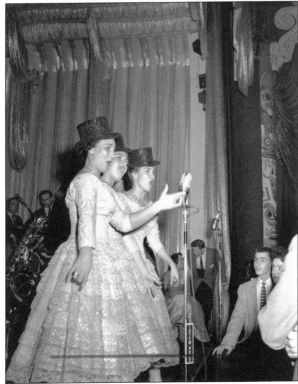

This trio of singers hams it up for an appreciative audience. Manager Roy Gill interspersed traveling acts with the Boston-based Totem Pole house band. This strategy saved money, as the house band cost less than a touring one. The Totem Pole itself, rather than a visiting band, became the main attraction. Couples came to dance and to experience the ambience.

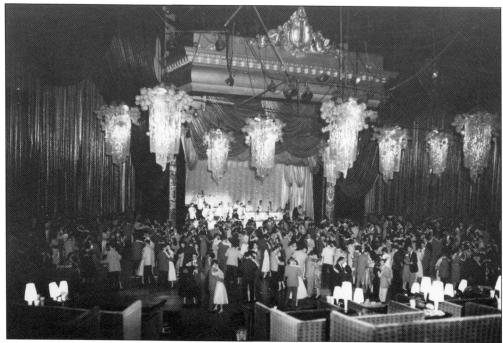

Many couples went on their first dates at the Totem Pole Ballroom. Barbara Donovan Shea remembered checking to make sure her stocking seams were straight when she went in 1946. Later the married couple returned to Norumbega Park with their children. Jerry Proulx remembered taking his future wife to hear Bob Bachelder on a "beautiful night" in 1955. "It was a wonderful, safe place to bring a date," he said.

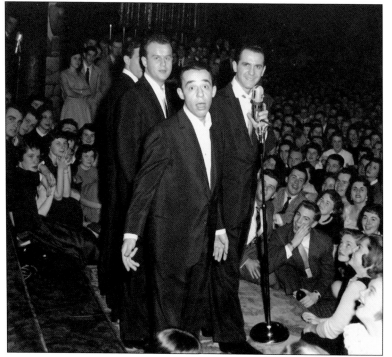

In the 1950s, the Four Lads brought a new sound to the stage, bringing fans who didn't want to dance. Ed Lynch, who worked at the Totem Pole, remembered, "Couples would be trying to dance, while other kids were sitting down on the dance floor waiting for the Four Lads or the Four Aces to come on. We would shoo them away, but five minutes later, they'd be back again."

Seven

FAREWELL TO THE PARK

After the end of World War II in 1945, attendance at both Norumbega Park and the Totem Pole Ballroom began a slow decline. As more people purchased cars and roads improved, a venerable local amusement park could no longer easily compete with newer attractions. As a result, Norumbega Park owner Roy Gill realized that the property might be more valuable for other activities. In 1949, he proposed developing a sports arena on the site of the park's ballfields. Newton residents, including 1,000 schoolchildren, vigorously protested this plan. The Newton Board of Aldermen voted down the project, but Gill's proposal publicly launched the idea that the park might change its focus.

At the Totem Pole, younger audiences drifted away as their tastes expanded beyond big bands. Television, regularly scheduled on networks starting in 1948, also kept people away from the Totem Pole. Though the ballroom frequently broadcast its performances on the radio, Gill missed his chance to broaden the appeal to television when he cancelled the live *Totem Pole Matinee* show in 1955 after only a year. A similar television show, *American Bandstand*, became a national hit soon after that.

In 1956, Gill sold Norumbega Park and the Totem Pole Ballroom to a group headed by businessman Doug Farrington, who had grown up in Newton. Though Farrington brought fresh ideas to both facilities, attendance continued to decline. As Newton added 10,000 residents between 1950 and 1960, the value of the land for development began to exceed the value of the park. Farrington's Norumbega Corporation sold to developer Peter Kanavos in 1960 but continued running the park and ballroom for the next three years.

Norumbega Park closed on Labor Day 1963. The Totem Pole closed soon after, in February 1964. Kanavos considered many proposals for the property but ultimately chose a hotel. Before the bulldozers arrived, fire destroyed the vacant Totem Pole building on November 10, 1965. Later, two additional buildings at Norumbega Park also suffered fire damage. The Marriott Motor Hotel began construction in 1966, officially ending more than 60 years of romance and recreation by the river.

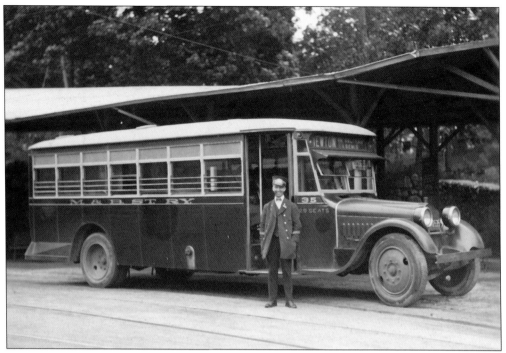

Though Norumbega Park was designed to entice people to ride the trolley, by 1924, residents began petitioning to remove streetcars from Commonwealth Avenue, claiming the noise detracted from their property values. In 1930, the streetcars were replaced with Middlesex & Boston buses. The new buses connected with the trolley lines at Lake Street.

As more patrons began driving to the park, Norumbega began catering more specifically to automobiles. It advertised free parking in its lot with space for more than 1,000 vehicles across from the main entrance on Commonwealth Avenue. A 1931 ad for the Totem Pole Ballroom tried to lure people who lived beyond Boston's public transit system, pointing out that the ballroom was only 45 minutes from Worcester.

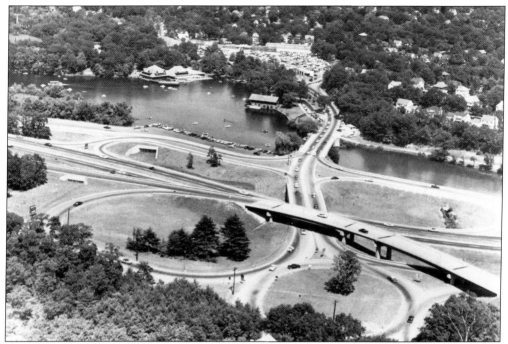

On August 23, 1951, Route 128, a new divided highway, opened between Wellesley and North Beverly. The road passed right through Auburndale, making it easier for people to get to Norumbega Park. Yet it also lured drivers elsewhere, to destinations that were once difficult to reach for a day trip, such as Boston's North Shore beaches, New Hampshire, and Maine.

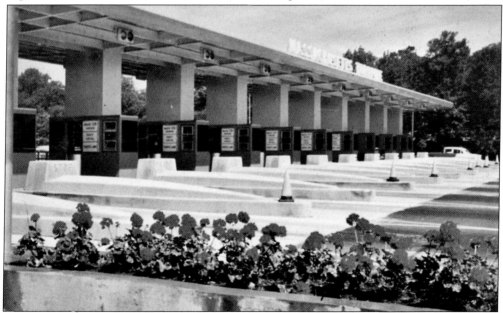

The Massachusetts Turnpike, which came through Newton in 1962, roughly following the east–west course of Commonwealth Avenue, also proved to be a mixed blessing for Norumbega Park. Though the Weston exit came close to the park, drivers needed an incentive to stop, and the park and ballroom were both on their way out by then.

In contrast to the swing bands, the Four Lads, who came to the Totem Pole in the late 1950s and early 1960s, inspired listening rather than dancing. Though the Canadian group often performed with an orchestra, their four-part harmonies defined their sound. They represented a new, younger style of music that helped signal that the era of big bands was over.

THE FOUR LADS • 1650 Broadway, New York City

After Doug Farrington, second from left, became the manager of the Totem Pole Ballroom, he continued to book swing bands, including one headed by Guy Lombardo, second from right. He later brought in groups that played new styles of music. An outdoor hootenanny, an informal gathering that highlighted folk music, was held in 1960 and brought several thousand young people to the park.

American folk music experienced a revival and became big business in the late 1950s and early 1960s as groups including Peter, Paul, and Mary began to make recordings that topped the *Billboard* charts. Their appearance at Norumbega Park drew a large crowd, but this showed up the limitations of the ballroom as a venue for this kind of music. People had to squeeze onto folding chairs on the dance floor.

A folk group, the Brothers Four, gave the final performance at the Totem Pole Ballroom on February 9, 1964. House bandleader Bob Bachelder performed elsewhere that night. One young audience member, Newton High School graduate Gail Shaw, became smitten with Brothers Four guitarist John Paine, right, and ended up marrying him 20 years later.

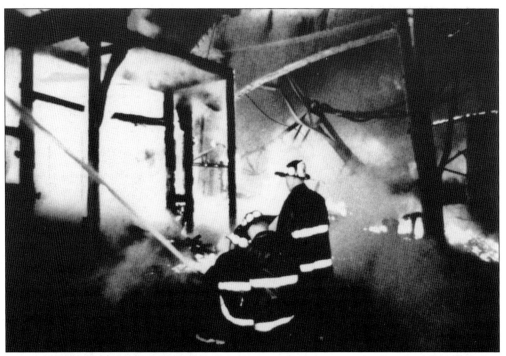

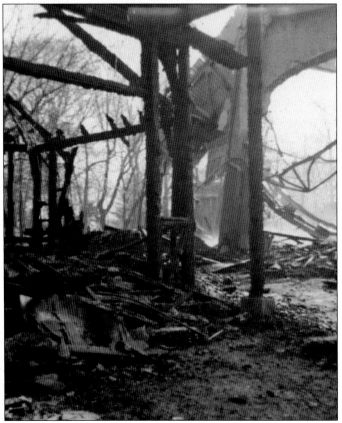

The fire that destroyed the Totem Pole Ballroom broke out around midnight on November 10, 1965, and burned for several hours. "The last dance of the old Totem Pole belonged to a thousand tongues of flame waltzing along the ballroom floor," reported the *News-Tribune* the next day. "Cars lined the northbound lane of Route 128 and couples sat and watched the image of a flaming hulk reflected in the waters of the famous duck-feeding [area] next to the dance hall. Flames could be seen for miles." Firefighters from Newton and six surrounding communities could not keep up as the roof sagged in and tiers surrounding the dance floor collapsed. Little remained except the steel structure. The fire's cause was never fully established.

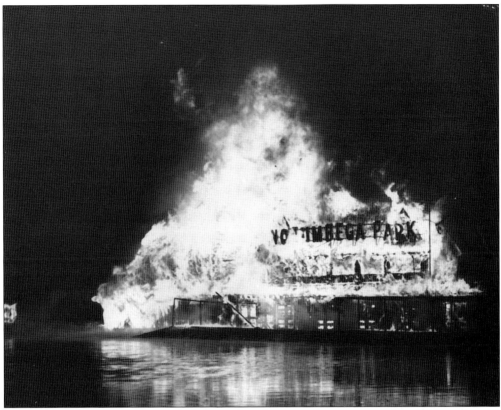

Just a few weeks after the Totem Pole burned to the ground, a suspicious fire on December 29, 1965, caused serious damage to the Normandie Room, the park's function hall. The building was later torn down. Another fire destroyed the Norumbega Park boathouse on June 1, 1966. Both may have been the work of vandals. (Photograph by John Whittenberg.)

The Newton Corporation, headed by Peter Kanavos, initially proposed redeveloping the Norumbega site into 12 high-rise buildings. Neighbors responded with flyers to "save Norumbega from the bulldozers and skyscrapers!" A proposal for the City of Newton to take the property by eminent domain failed. A later plan for a Kanavos venture with the Marriott Corporation to build a $4-million motel on the site received necessary approvals in 1966.

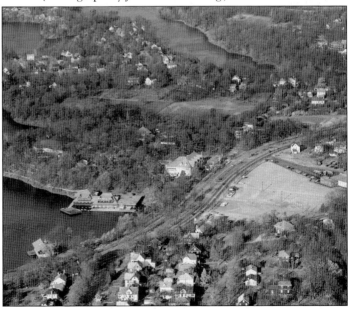

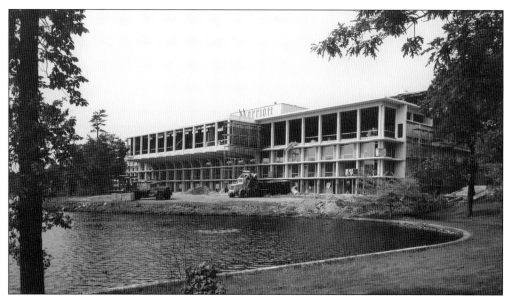

Ground-breaking ceremonies for the new Marriott Motor Hotel took place on May 23, 1967. Massachusetts governor John Volpe, Newton mayor Monte Basbas, and Marriott president J.W. Marriott Jr. all attended, showing their support for a new business destined to attract tourists. The City of Newton acquired 13 acres of former park land for the Norumbega Conservation Area around 1975.

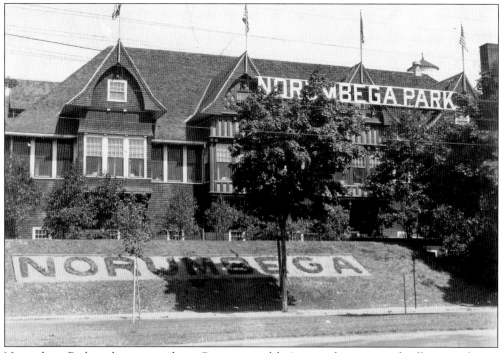

Norumbega Park no longer stands on Commonwealth Avenue, but patrons fondly remember it. Volunteers re-created the ballroom inside the Marriott Hotel in 1988 and again for a diamond jubilee in 1990, when former bandleaders Bob Bachelder and Baron Hugo performed. The park and the ballroom remain magical places, especially in memory.